IMAGES
of America

METAIRIE

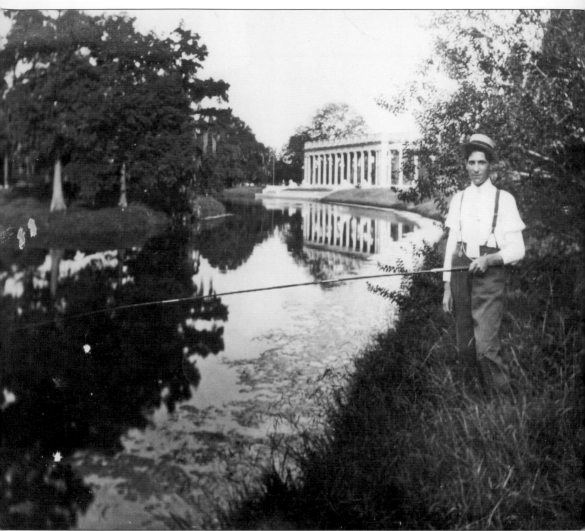

ON THE COVER: The last remaining vestige of ancient Bayou Metairie can be seen in this *c.* 1910 image from the Harry D. Johnson Photograph Collection in the New Orleans Public Library. The Peristyle, built in 1907 as a dancing pavilion, and the bayou still remain just steps away from City Park Avenue. In the past, the bayou flowed from the Mississippi River at what is now Kenner, through Metairie, and along present-day Metairie Road and Metairie Cemetery before terminating at Bayou St. John. (New Orleans Public Library [NOPL].)

IMAGES
of America

METAIRIE

Catherine Campanella

ARCADIA
PUBLISHING

Published by Arcadia Publishing
Charleston SC, Chicago IL, Portsmouth NH, San Francisco CA

Printed in the United States of America

Library of Congress Catalog Card Number: 2007939173

For all general information contact Arcadia Publishing at:
Telephone 843-853-2070
Fax 843-853-0044
E-mail sales@arcadiapublishing.com
For customer service and orders:
Toll-Free 1-888-313-2665

Visit us on the Internet at www.arcadiapublishing.com

To Mike

CONTENTS

Acknowledgments 6

Introduction 7

1. From New Orleans to Jefferson and Back 9

2. Bucktown, East End, and West End 39

3. Old Metairie 49

4. Airline Highway 79

5. Veterans Highway and the Causeway 109

Bibliography 127

ACKNOWLEDGMENTS

Metairie, with its small-town feel and easy access to the city, was a great place in which to grow. All but a few parents of first-generation "Metairians" (myself included) were born and raised in New Orleans. Most of my neighborhood peers were New Orleans natives because there were few hospitals in Metairie when they were born. Until the late 1950s, most inhabitants of Metairie shopped, went to theaters, attended high school, and worked in the city. Metairie was the proverbial bedroom community and would be just another American suburb but for its connection to the unique and historic city of New Orleans.

In the New Orleans state of mind, we are all from the same place, the same community. We cherish that connection first and foremost and then identify with the microcosms known as faubourgs, neighborhoods, and suburbs, which were the result of New Orleans's outward growth from the original town square. We are who we are, eat what we eat, love a good time, and talk as we do because we are New Orleanians. In these acknowledgments, I would be derelict in not including these observations and giving thanks.

I must add that Metairie does in fact have a history apart from New Orleans (otherwise, this book would not have been written). Researching the modern history of an area is tricky because facts and figures set down in the recent past often conflict. The information found here is, to the best of my knowledge, correct. Photographic sources include, among others, the New Orleans Public Library (NOPL); the University of Tennessee Library's Perry-Castañeda Library Map Collection (UTLPC); the Louisiana State University School of Landscape Architecture, Office of Sea Grant (LSUSLA); the Louisiana Digital Library (LDL); the Library of Congress (LC); and the Jefferson Parish Yearly Review (JPYR). Uncredited photographs are from the author's collection.

Special thanks go to Irene Wainwright, archivist of the New Orleans Public Library, for assistance in acquiring the cover image. Invaluable information was generously shared by the following: Chuck Azzarello, Mike Azzarello, Meredith Campanella, Vincent Campanella, Rita Tonglet, Charles B. Dupré, Henry Harmison, Elizabeth Fury, Gene Benefield, John Guignard, Sandra Sporl Middleton, Mary Fury, Lawrence Englert, Maria Vieages, Connie Adorno Barcza, Elizabeth Ohmer Pellegrin, Vern Tripp, Harry Breaux, and Dolly Breaux. (I do not know how I could have written this book without you.)

INTRODUCTION

While traveling on Metairie Road, one follows the trail used by Native Americans long before people on other continents knew of their existence. The road sits upon the Metairie Ridge, a naturally occurring deposit of alluvial soil created thousands of years ago. The oak trees are of the same natural stand that graces City Park. Until modern times, a bayou flowed along the road; the only remaining section of it is in the park. Formed around 2500 BCE, it has been called Bayou Metairie for centuries.

Continuing down the ancient path, the Seventeenth Street Canal marks the entrance into the city of New Orleans, but the street name remains Metairie Road. Metairie Cemetery comes into view; from 1838 until 1873, the property was occupied by the Metairie Race Course. Until 1874, this area of the city was a part of Jefferson Parish and the bayou still flowed. At the Interstate 10 overpass, the street name changes to City Park Avenue (until 1902 it was Metairie Road).

It is not surprising that many residents of Metairie consider themselves to be New Orleanians because their histories are intermingled. All of what we now call Carrollton, Uptown, the Garden District, and the Irish Channel, as well as parts of Mid-City and Central City (all west of Felicity Street), were Jefferson Parish property when the jurisdiction was carved out of the parish of Orleans in 1825. New Orleanians had, for generations, moved westward from the original city (the French Quarter) to newly opened areas of land.

The origin of the name Metairie is debatable, but most historians attribute it to either the French *moitie*, "one-half," or *moitoire*, a 12th-century word applying to land leased to a farmer for 50 percent of the crops or produce grown. Although farming was a major endeavor for most of Metairie's long history, sharecropping was not commonly practiced.

It may be of interest to note that in 1682 Jacques de la Metairie traveled with René Robert Cavelier, Sieur de La Salle, to the mouth of the Mississippi River, where, serving as the explorer's notary, he officially recorded the claim of the land for France in the name of King Louis XIV. However, no historic record indicates that the place name Metairie was given for or by him.

After New Orleans was founded in 1718, the French government granted lands to be used for large agricultural endeavors. The Jesuit Fathers' property, deeded in 1726, was called Metairie des Jesuites, and land granted to the Chauvin family in the same year was called La Metairie. By the 1760s, when farming had been well established in the area, Metairie appeared frequently on maps and in official documents. Spelling variations have included Maiterie, Meteria, Maitry, Matery, Materie, Metry, and Maitery. Metairie was originally called Tchoupitoulas (or a variation of the word) for the Native Americans who had lived along the road, the bayou, and in the surrounding area.

Despite it's long agricultural history, few plantation homes were built in Metairie. They were constructed near the Mississippi River, but the properties often extended through Metairie to Lake Pontchartrain. Dense forests provided lumber, some of it used to build the first church in New Orleans. Until the early 1900s, many small farms produced lettuce, cabbage, shallots, onion, beans, cucumbers, and artichokes. Some land was used as pasture for milk cows and for dairies.

Small truck farmers plodded along unpaved roads for as long as six hours to transport their goods by horse and wagon to the French and Treme Markets.

For almost 200 years—from 1723, when the first agricultural land was deeded, until around 1910—Metairie remained primarily farming, pasturing, and timbering land. This began to change when a streetcar—an extension of the Napoleon Avenue line from New Orleans—was placed along Metairie Road in 1916, allowing easy access to what was a remote area. The first modern property developments (subdivisions of sorts) began during the 1920s on land directly adjacent to New Orleans. On its opposite boundary, at the old town of Kenner, some growth edged over the line into Metairie. Much of the land, however, remained undeveloped until the mid–20th century, when lowland swamps and marshes on either side of the ridge were drained.

After World War II, as young soldiers returned home to New Orleans and began raising families, they faced a housing shortage. Like many of their parents and grandparents before them, they moved slightly westward. Using GI Bills, they acquired new and affordable homes on larger lots than were usually available in the city. From the 1950s through the 1970s, the area boomed with subdivisions comprised mostly of ranch-style houses (the new residents, unfortunately, did not take the architectural traditions with them to Metairie). This trend continued until all the swampland was drained and all but a tiny percentage of ancient cypress and oak trees were cut and cleared.

The seemingly haphazard growth of Metairie (many businesses along the major thoroughfares did sprout up in an unplanned configuration) belies the "build it and they will come" foresight of Jefferson Parish officials, who had dug canals, drained swamps, and built major roads years before the vast majority of the area was populated. They vigorously promoted their parish and invited newcomers and new businesses. Between 1940 and 1950, the population of Jefferson Parish more than doubled, just as it had between 1920 and 1930. In 1954, Dun and Bradstreet ranked Jefferson Parish the "busiest parish" with a 42.3-percent gain in business listings.

In 1954, the Jefferson Parish Address Co-ordination Section changed some street names that were duplicated and reassigned some addresses. Streets starting at Airline Highway were addressed as the 100 block at Airline and increased toward the lake. Streets starting at the river were addressed as 100, also increasing toward the lake. Streets crossing Airline Highway were designated as "north" at that point toward the lake. East-west running streets started as the 100 block at the New Orleans parish line and increased toward Kenner.

Metairie's 3,240 acres stretch some eight miles between the cities of Kenner and New Orleans. Airline Drive is its southern border, and Lake Pontchartrain lies to the north. Metairie is an unincorporated area; it is not a city—there is no mayor or city tax. It is governed by the Jefferson Parish Council. Metairie Ridge was incorporated in 1927 for the sole purpose of obtaining gas service (with C. P. Aicklen serving as mayor) and was then unincorporated several months later.

People as diverse as David Vitter and Ellen DeGeneres were born in Metairie, but arguably the most colorful and beloved local figure was Harry Lee. As this book was being finalized, Jefferson Parish sheriff Harry Lee passed away after a valiant battle with leukemia. He will long be remembered as a strong leader and New Orleans character who never failed to speak his truth (his was a non–politically correct mind). After Sheriff Lee's death, even those who disagreed with him in life praised his honesty, his dedication, and his commitment to serve the community.

Before the levees and floodwalls broke in the aftermath of Hurricane Katrina, it is likely that few citizens outside of Louisiana had ever heard of Metairie. During those horrific days following one of the most devastating manmade catastrophes in history, broadcasts of the Seventeenth Street Canal failure and images of thousand of citizens amassed at Causeway and Interstate 10 awaiting transportation out of the area have imprinted Metairie in the minds of countless observers. This book will hopefully leave readers with better memories of Metairie's history.

One

From New Orleans to Jefferson and Back

The first record of the land that would become Metairie is the Concession of 1720, called the Chapitoulas Concession for the "river people" who lived along the bayou and the high natural ridge that cut through the swamps on either side. The ridge and bayou ran from the Mississippi River near what is now Kenner to Bayou St. John. Through the years, Chapitoulas evolved into Tchoupitoulas. No place in modern-day Metairie holds that name, but in New Orleans, Tchoupitoulas Street follows the river from Audubon Park to the Warehouse District.

Bayou Tchoupitoulas was later known as Bayou Metairie, and the top of the ridge became Metairie Road. Europeans first dammed the bayou at the river in order to drain land for farming. Until the 1950s, the bayou still flowed beside Metairie Cemetery until it was filled to widen Metairie Road. All that remains of it is a sliver in City Park along City Park Avenue.

Until 1825, all of what is now Metairie, as well as land to the east as far as Felicity Street in New Orleans, was included in the parish of Orleans. At that time, the land was divided to create Jefferson Parish, which included the former New Orleans cities of Lafayette, Jefferson, and Carrollton.

The city of Lafayette, now the Garden District and the Irish Channel, served as the first seat of Jefferson Parish government. The Egyptian-Revival Jefferson Parish Courthouse, at 2219 Rousseau Street, still exists. Jefferson City was bordered by Lowerline Street, Washington Avenue, Toledano Street, and the Mississippi River. The city of Carrollton acted as the seat of Jefferson Parish government from 1852 to 1874. The parish courthouse, located at 719 South Carrollton Avenue, now serves as an Orleans Parish school building. In the early years, Carrollton was a popular resort destination with a hotel, gardens, beer gardens, the first streetcars as we know them today, and a train station. Northline Street in Metairie marked the northernmost boundary of the city of Carrollton. In 1874, after having changed several times, the eastern boundary of Jefferson Parish was set at the Seventeenth Street Canal and Monticello Avenue.

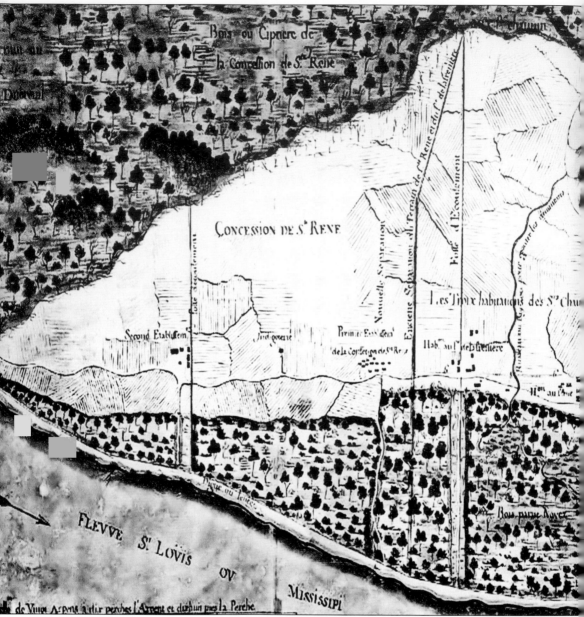

The Canadian Chauvin brothers—Nicolas Chauvin de La Freniere, Louis Chauvin de Beaulieu, and Joseph Chauvin de Lery—followed Jean-Baptiste Le Moyne, Sieur de Bienville, to the site he would claim for France and name New Orleans. From Bienville they acquired the land that lies in the right portion of this 1726 map of the Chapitoulas Concession. Also known as the Tchoupitoulas Concession, it included land that is now Metairie. The lighter sections of the map fall south of Bayou Metairie (and the Metairie Ridge), which ran along the present Metairie Road (then called the Chemin des Chapitoulas) and City Park Avenue, where it joined the Gentilly Bayou and ridge along what is now Gentilly Boulevard. The concession of 1720 was the first grant upriver from the city of New Orleans. Land along it was called the Chapitoulas/Tchoupitoulas Coast. The St. Rene (also called St. Reyne and Sainte Reyne) Concession can be seen on the left side of the map. (Smithsonian Institution [SI].)

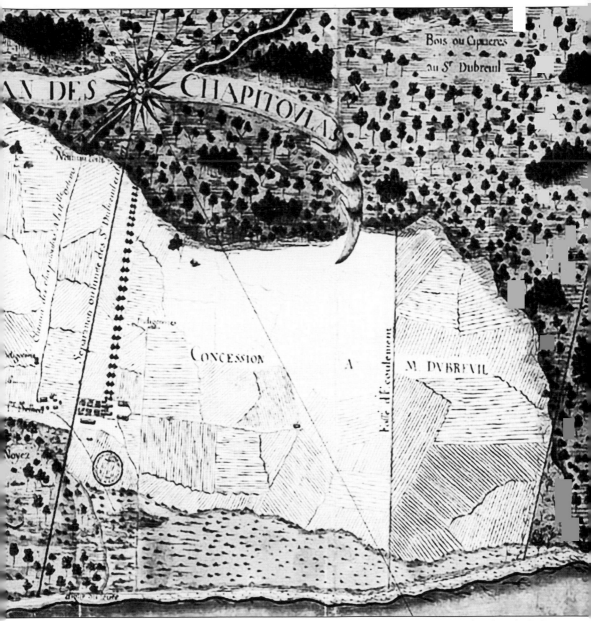

The grants extended from the river to the lake. Nicholas Chauvin De La Freniere's land included 5,000 acres; his home was known as the Elmwood/Lafreniere Plantation (built in what is now River Ridge). While clearing the cypress swamp on which he would grow indigo and sugar cane, he donated the lumber to build the first church in New Orleans (later replaced by St. Louis Cathedral). He also held the first tavern permit in Louisiana. La Freniere's sister Barbe Therese and her husband, Ignace Hubert de Bellair, were early settlers; Bellair Drive was named after them. Claude Joseph Villars Du Breuil, who by 1744 owned several plantations growing indigo and sugar with 500 slaves, reportedly had the finest home on the Tchoupitoulas coast. Du Breuil also built the first plantation levee, which led to the creation of the Mississippi River levee system in 1724. Bienville's land is visible on the right edge of the map. (SI.)

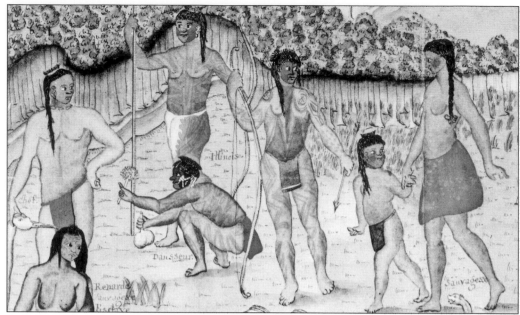

In 1885, Norman Walker wrote, "On bayou Tchoupitoulas, which courses through the suburbs of the city, emptying into Lake Pontchartrain, are to be found relics of the old Indian town Tchoutchouma, or 'the city of the sun,' which antedated by countless centuries 'the Crescent city.' Here are primeval shell-mounds and Indian burial-grounds, still well-stored with prehistoric bones, the re-mains, perhaps, of some feast of those Louisiana cannibals, the Attakapas (man-eaters), of whom the French settlers were so much in dread." Walker was describing another bayou named Tchoupitoulas that flowed in what is now the Causeway/Lakefront area. Above is a 1735 watercolor by Alexander de Batz entitled *Indians of Several Nations Bound for New Orleans 1735*. Below is a modern view of the only remaining segment of Bayou Tchoupitoulas/Bayou Metairie as it runs through City Park beside the Peristyle. (Peabody Museum, Harvard.)

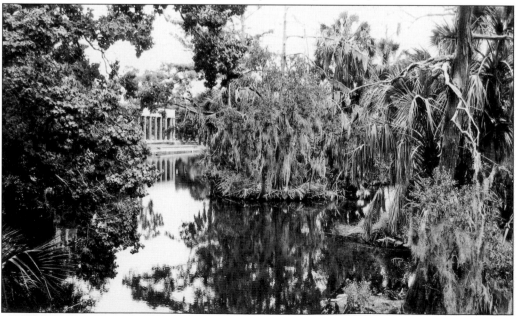

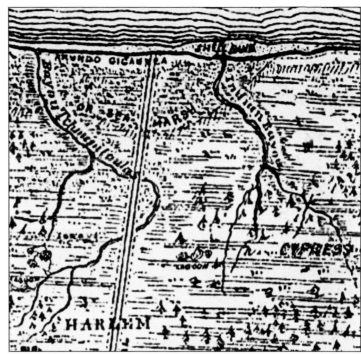

The right detail from an 1849 map shows the Bayou Tchoupitoulas that Walker described above. East of this bayou, Indian Bayou and a shell bank can be seen. The land shown here now includes the Causeway and Bucktown areas. Below is a 1954 view of boaters passing an as-yet-undeveloped Lake Pontchartrain shoreline in Metairie. (Right UTLPC; below LDL.)

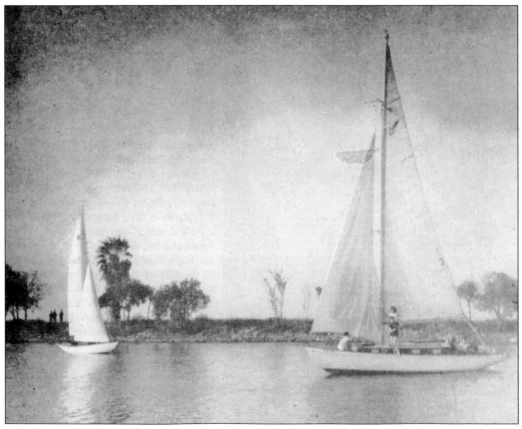

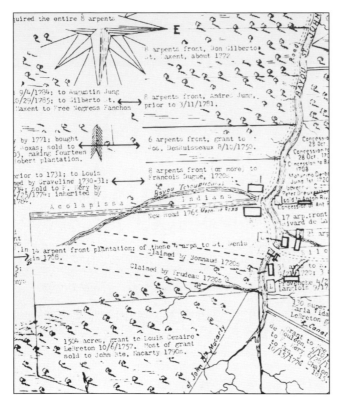

Copied and translated from a Spanish-drawn map of 1798, the above image reveals that Metairie Road was named centuries ago. It was originally referred to as Chemin de Tchoupitoulas, or "fish hole." We also see that Bayou Metairie was known as Bayou Tchoupitoulas. In fact, the entire Metairie area was originally called Tchoupitoulas. The map indicates a "new Road 1765" (Metairie Road) and the presence of "Acoloapissa Indians." Bayou St. John runs north to south in this illustration. Early land grants and concessions are also visible here. Below is another 1798 view of the bayou and road. (Above LC; below UTLPC.)

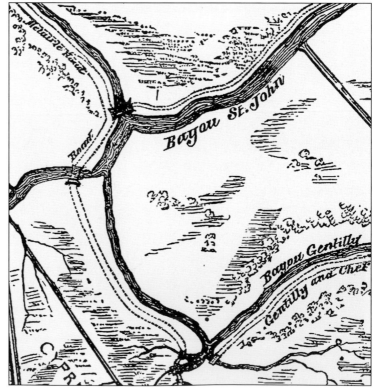

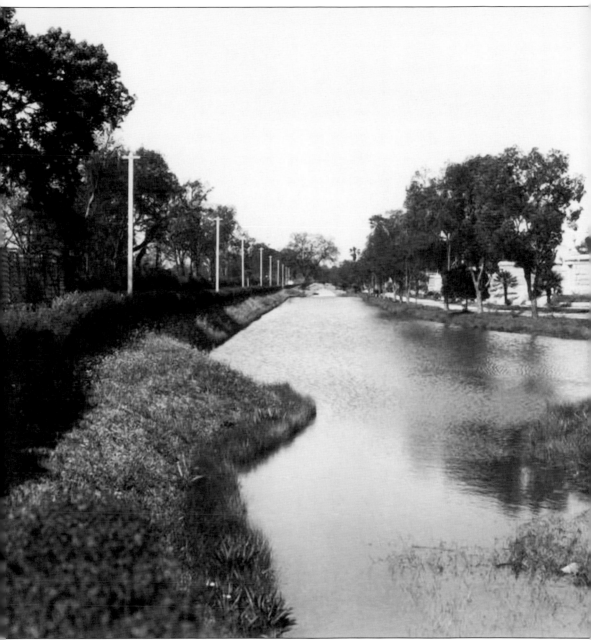

In this 1930s view of Metairie Cemetery, Bayou Metairie flows along Metairie Road. The bayou pictured here was covered during the 1950s in order to widen the road. When traveling in the northernmost lane and passing the cemetery, one rides upon the ancient Bayou Metairie. (LDL.)

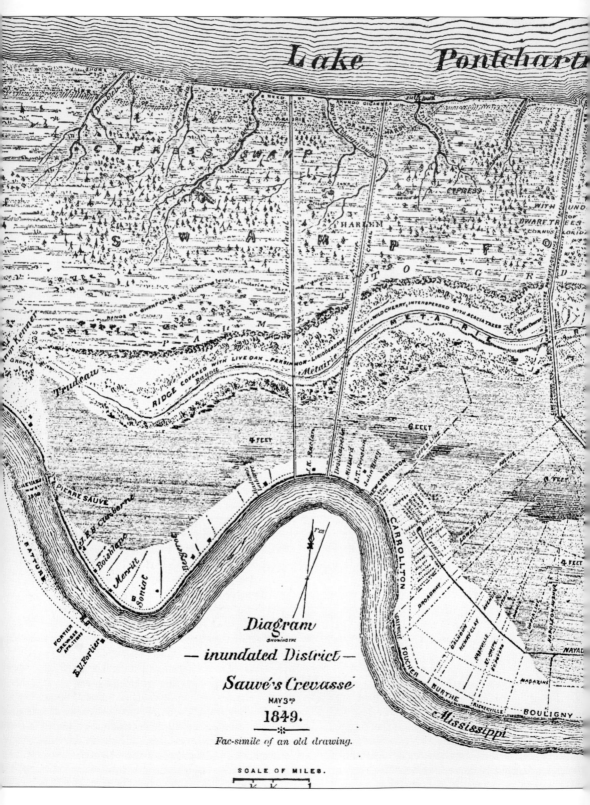

Diagram
SHOWING THE
— inundated District —
Sauvé's Crevasse
MAY 3RD
1849.
Fac-simile of an old drawing.

SCALE OF MILES.

This map of the Sauve Crevasse has become well known because the floods of 1849 so closely duplicated the results of the floodwall and levee breaks in the aftermath of Hurricane Katrina. Various natural bayous in Metairie (now filled) fed by the lake are visible, including Double Bayou, Bayou Luria, Bayou Tchoupitoulas, and Indian Bayou (just right of upper center) with its shell bank (also known as Indian Beach). Indian Beach still appears on many modern maps. It was located in present-day Bucktown near Bonnabel Boulevard and the lake. By 1886, when this map was produced, two canals (left of center) had been dug in Metairie and can be seen here running north to south between the lake and the river. Bayou Metairie, Metairie Road, and Metairie Ridge run east to west from Bayou St. John to Kenner. (UTLPC.)

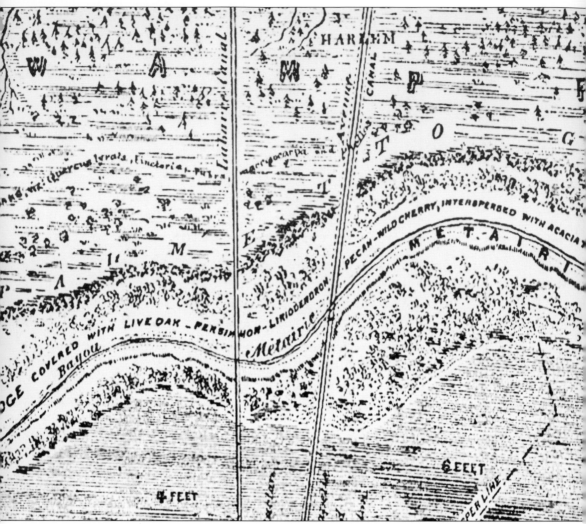

Near the top center of this map detail, the Harlem district, which now includes Shrewsbury and Causeway Boulevard, can be seen. Until the mid-20th century, Causeway Boulevard was named Harlem. The map notes, "Ridge covered with live oak—persimmon—wild cherry, interspersed with acacia trees." Four to six feet of standing water is indicated south of Metairie Road in the 1849 Mississippi River flood map. This closely parallels the post-Katrina flooding. (UTLPC.)

To the far left is the land deeded to Minor Kenner (with a magnolia grove) that would become the city of Kenner. Louis Trudeau's land is just east of Kenner's property. Pierre Sauve owned the land where the crevasse occurred; this is now River Ridge. Other land owners whose names are still familiar to local residents include Soniat and Labarre. The New Carrollton and Carrollton areas can be seen on the far right. (UTLPC.)

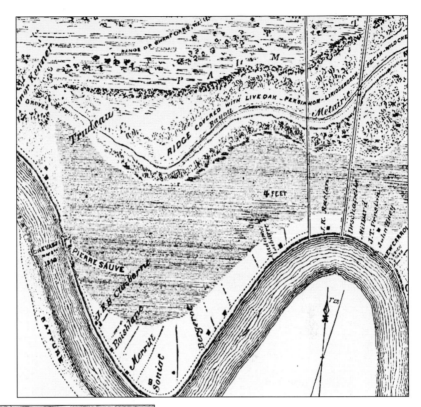

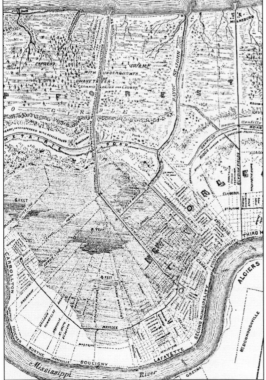

In this Sauve's Crevasse map detail, the Metairie and Gentilly Ridges run east to west, converging at Bayou St. John. The Carrollton and Lafayette sections (lower portion), as well as the faubourgs between them (which would become the city of Jefferson), were annexed from the parish of Orleans when Jefferson Parish was established in 1825. (UTLPC.)

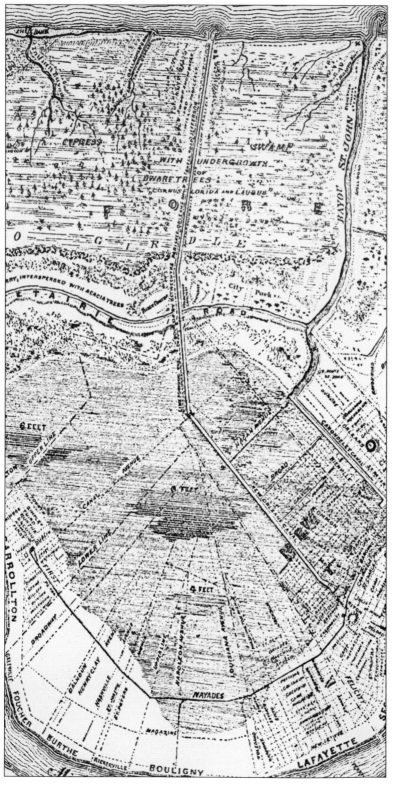

Here the New Basin Canal (also called the New Orleans Canal) runs north to south and terminates at West End on the lake. It acts as the boundary between Orleans and Jefferson Parishes until veering to the right near the center of the map. From there, the line extends toward Felicity Street to the river (lower right corner). The present Interstate 10 Pontchartrain Expressway and Pontchartrain Boulevard now follow the path of the canal, which was covered during the 1950s. The modern-day West End, as well as land west of Felicity Street, was within the Jefferson Parish boundary when the parish was created in 1825. The current boundaries were set in 1874. (UTLPC.)

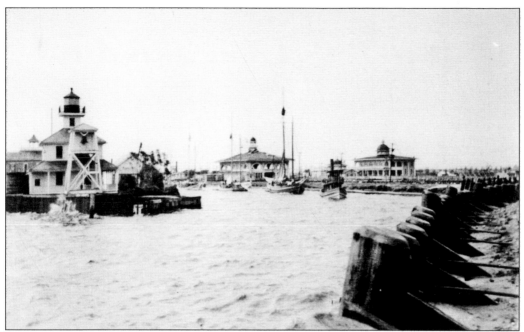

The *c.* 1890 image above, depicting the New Basin Canal as it meets Lake Pontchartrain, includes views of the New Canal/West End Lighthouse (left), Mannessier's Pavilion (center), and the West End Hotel. The New Canal Lighthouse was added to the National Register of Historical Places in 1985. Below is an engraving featuring a boat race on the canal. (NOPL.)

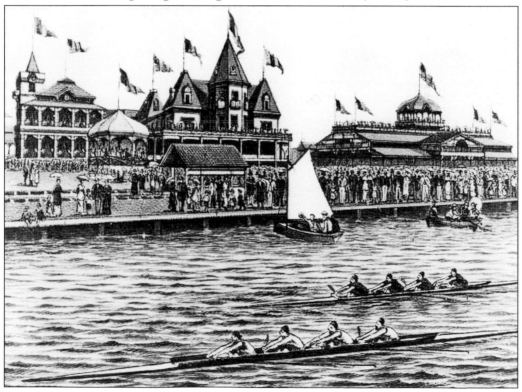

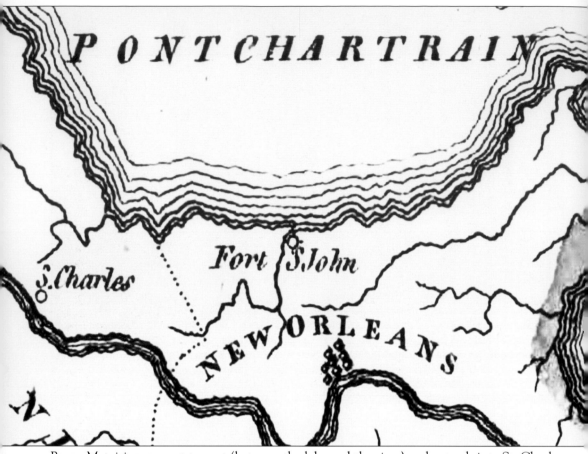

Bayou Metairie runs east to west (between the lake and the river) and extends into St. Charles Parish in this 1814 map. Land that would later become Jefferson Parish is, at this time, contained in the Third Senatorial District of the parish of Orleans. (UTLPC.)

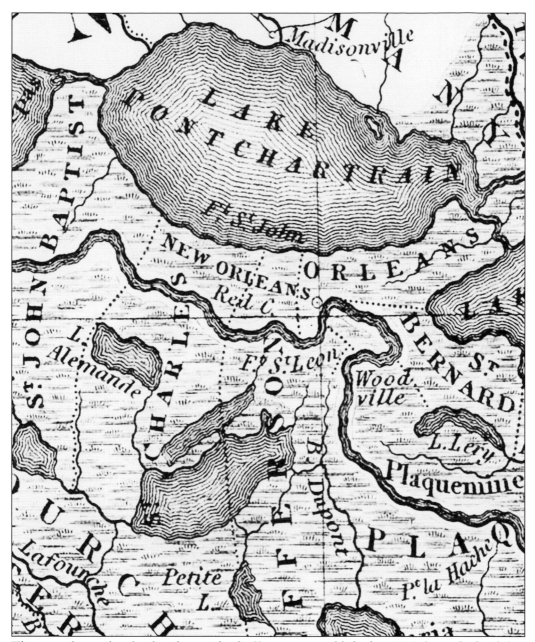

This map, drawn shortly after the parish of Jefferson was established in 1825, shows the land that had been taken from Orleans Parish. First proposed as Tchoupitoulas Parish, it was instead named to honor Thomas Jefferson for his work in negotiating the Louisiana Purchase. St. Bernard and Plaquemines Parishes were also originally contained in Orleans Parish. (LDL.)

From the New Orleans Public Library, this ward map clearly shows the boundary between Orleans and Jefferson Parishes in 1847. The parish line follows the New Basin Canal (now Pontchartrain Boulevard) and Felicity Street. All land to the left of the boundary line belonged to Jefferson Parish; prior to this time, Metairie had been part of the parish of Orleans since the early 1700s. (NOPL.)

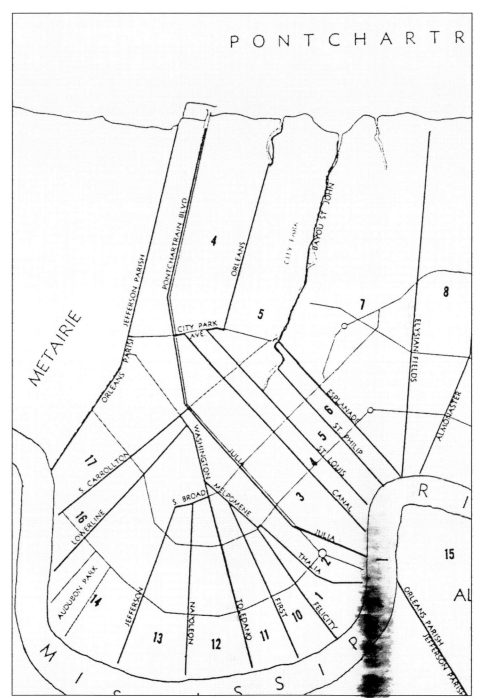

In this 1880 view of the parish boundary, the northernmost line has shifted from Pontchartrain Boulevard (formerly the New Basin Canal) to the Seventeenth Street Canal. This accounts for the West End area often being referred to, during the 19th through the mid–20th century, as East End (the eastern end of Jefferson Parish). The lower parish line has swung dramatically to the west. The city of Carrollton, Jefferson City, and Lafayette City have been returned to New Orleans. (NOPL.)

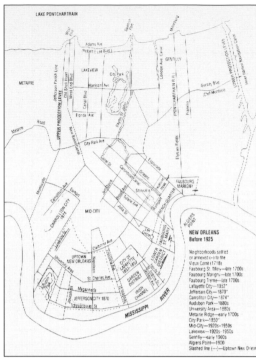

This diagram lists areas as they were settled or annexed to New Orleans. Lafayette City was returned to Orleans Parish in 1852. Jefferson City was annexed from Jefferson Parish in 1870. Carrollton City was removed from Jefferson Parish four years later. Note that Mid-City and Lakeview did not begin to develop until the 1920s—they are newer than the older parts of Metairie. (NOPL.)

A closer view of the city of Carrollton can be seen just right of the curve in the river in 1849. Carrollton was incorporated as a Jefferson Parish town in 1845 but had in fact been part of Jefferson Parish since its creation in 1825. Carrollton served as the seat of Jefferson Parish government until it was annexed back to New Orleans in 1874. Upperline and Lowerline Streets were so named because they served as Carrollton city boundaries. (UTLPC.)

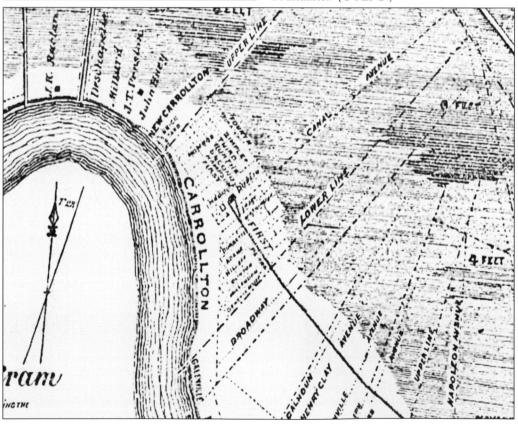

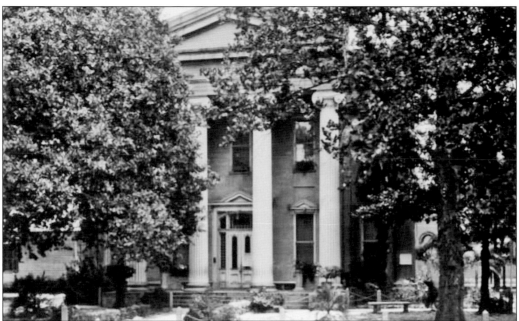

The historical marker on the neutral ground of Carrollton Avenue between Hampson and Burthe Streets reads, "Laid out by Charles Zimpel in 1833 on site of Macarty Plantation, formerly uppermost part of Bienville's 1719 land grant." The land was granted by Spain to Jean Baptiste Macarty in 1795. The photograph above gives us an early 1920s view of the Jefferson Parish courthouse, designed by Henry Howard in 1854, which is located at 719 South Carrollton Avenue. After Carrollton was annexed back the Orleans Parish, the building served as schools; McDonogh 23, Benjamin Franklin, and Lusher Elementary School Extension. Pictured below is a 1930s view of the Macarty plantation, which served as St. Mary's Orphan Home during the mid-1800s, which was administered by the congregation of the Holy Cross. This home served as General Jackson's headquarters during the War of 1812. Also of note, German emigrant Theodor Bruning opened his first restaurant on Claiborne Avenue during the 1840s in what was then the town of Carrollton. (LDL.)

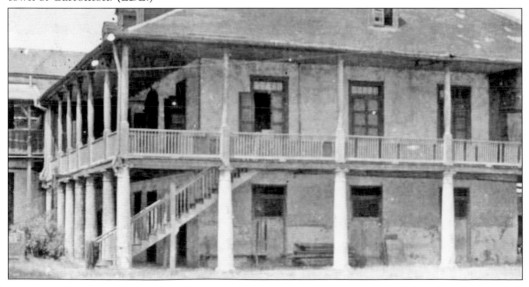

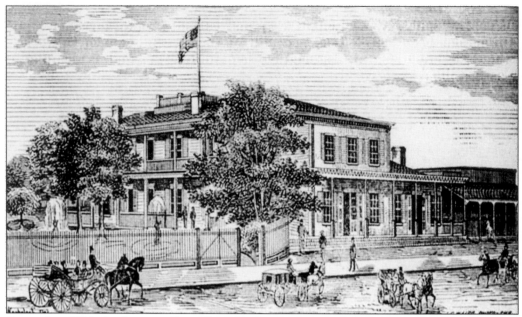

Opened in 1836, the four-acre Carrollton Gardens and resort included a hotel (pictured), livery stable, pigeonnier, steamboat landing, and ticket office. The resort was developed by the New Orleans and Carrollton Railroad Company (NOACRRC) when the first tracks were laid to Carrollton. The levee along the gardens was planted with rows of china ball trees. The resort was demolished to make way for levee improvements in 1891. (LDL and NOPL.)

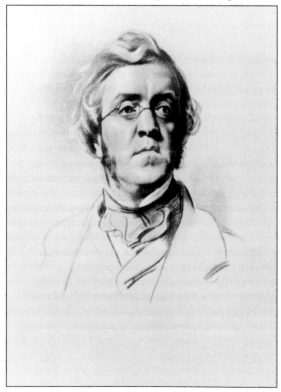

The Carrollton Hotel burned in 1841 but was rebuilt by Dan Hickock, who hosted luminaries such as Zachary Taylor and William Makepeace Thackeray (pictured) during an 1855 visit. An 1891 New York Times article noted that during the 1840s, "West End was a bog and Spanish Fort was chiefly populated by mosquitoes. Milneburg was just beginning to give promise of the future greatness which awaited her. There was no rival to compete with the gardens." City-dwellers could ride to Carrollton on the steam-powered railcars ("dummies"), which had replaced horse-drawn cars in 1845. During the late 1800s, electric streetcars began running along this line. The Carrollton Historic District and the streetcars originating there (the St. Charles Streetcar Line, the Carrollton Line, and the NOACRRC) have been designated National Historical Places. (LC.)

East of Carrollton, the faubourgs of Greenville, Foucher, Burthe, Rickerville, and Bouligny were incorporated as Jefferson City in 1850. Like Carrollton, this area had been a part of Jefferson Parish since 1825. Jefferson City returned to Orleans Parish in 1870, first being named the borough of Free Port. Nayades Street was later renamed St. Charles Avenue. (UTLPC.)

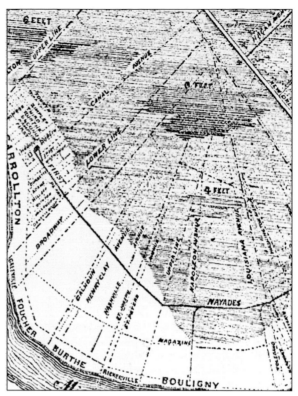

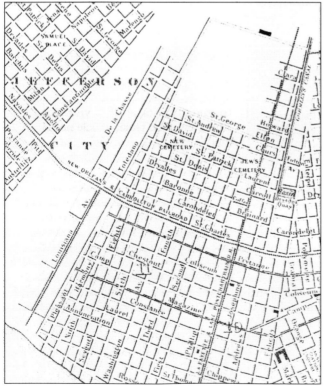

This close-up view of an 1855 map shows some of the streets in Jefferson City. The city's outermost borders were Lowerline Street, Washington Avenue, Toledano Street, and the Mississippi River. Landowners of note included Philippe Pierre August Delachaise, Marie Antonine Foucher, Dr. Thomas Peniston, Laurent Millaudon, Valmont Soniat de Fossat, Cornelius Hurst, and Dominique Francois Burthe. All of their names were given to streets. (LDL.)

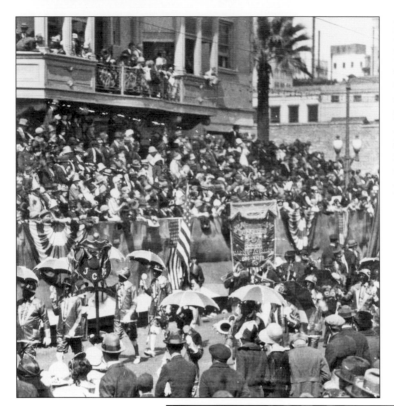

Established in 1890, the Jefferson City Buzzards comprise the oldest New Orleans Carnival marching club. Their 5-mile route from headquarters at 5801 Tchoupitoulas Street ends on Poydras Street. At Canal Street, they precede the Rex parade. (LDL.)

Before incorporation as the Jefferson Parish city of Jefferson, the area was known as the Faubourg Bouligny, named for plantation owner Louis Bouligny. When it was subdivided, some streets were named for Napoleon's victories: Austerlitz, Jena, Valence, Cadiz, and Marengo. Napoleon Avenue was one of the area's major streets. Jefferson City included what we now call Uptown New Orleans. Here the Jefferson City Buzzards are marching in 1925. (LDL.)

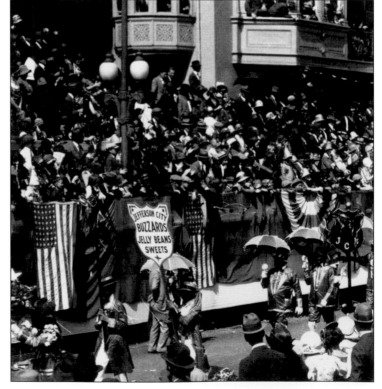

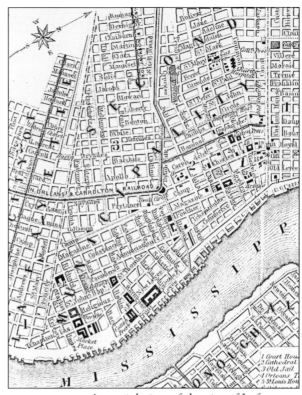

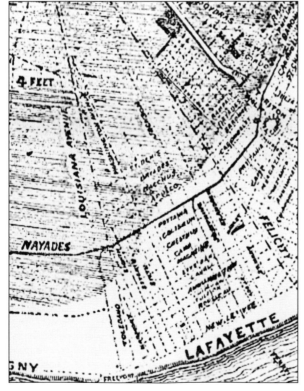

A partial view of the city of Lafayette is seen above on the bottom left. Felicity Street served as the western border of New Orleans—land west of it was a part of Jefferson Parish. This map was created 1845. Lafayette was incorporated as a city in 1833. It was annexed to New Orleans in 1852. The Jefferson Parish City of Lafayette is outlined on 1845 map below. Jefferson City was bounded by Toledano Street, Melpomene Street, Felicity Street, and the river— forming what is now called the Garden District and the Irish Channel, both of which have been placed on the National Register of Historical Places. (UTLPC.)

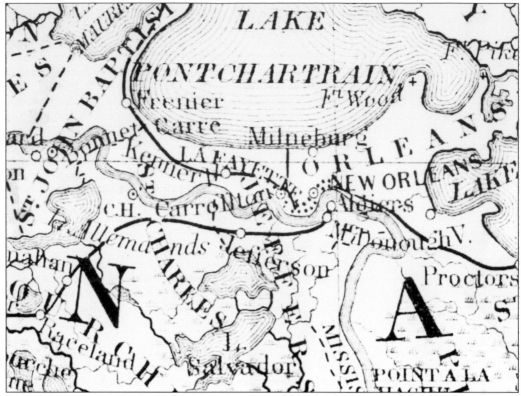

Dark areas indicate land inundated in the September 1723 hurricane that destroyed much of the tiny city of New Orleans. It has been estimated that over 150 hurricanes and tropical storms have struck or come very near the Louisiana coast since recorded history. Note that Carrollton and Lafayette are included in Jefferson Parish in this 1845 map. (LDL.)

The first seat of Jefferson Parish government was in the city of Lafayette. Pictured is the 1836 Egyptian Revival–style Jefferson Parish Courthouse, located at 2219 Rousseau Street in the present-day Irish Channel. The building is included in the National Register of Historical Places. (LC.)

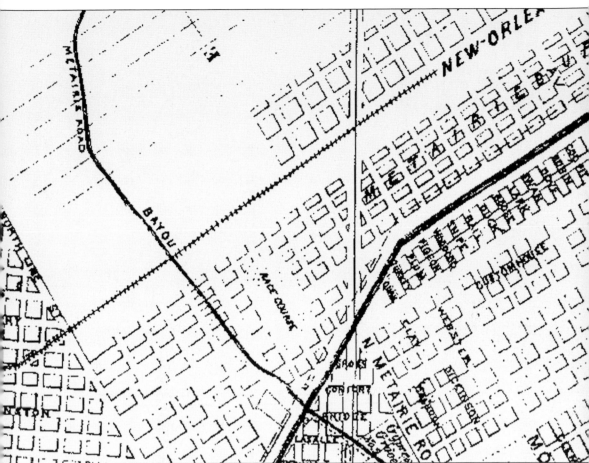

The oval shape below the center of this section detail from an 1867 map is the Metairie Race Course. It was first named the Bingaman Course for Natchez farmer and horse owner Col. Adam L. Bingaman. The land was acquired from the N. O. Canal and Banking Company in 1838, and 10 years later, it was turned over to Richard Ten Broeck, who established a joint-stock company with full control of the course. In 1851, the grandstand was refurbished. Special stands and parlors "for the ladies" were added, making the track a popular venue for all. The Metairie Race Course was one of the south's leading tracks. The course was so popular that the nearby Union Track (later named the Fair Grounds) was unable to compete successfully and closed from 1857 to 1859; it was purchased by the Metairie Trotting and Pacing Club and renamed the Creole Race Course. The land containing the Metairie Race Course was converted into Metairie Cemetery in 1873. (LDL.)

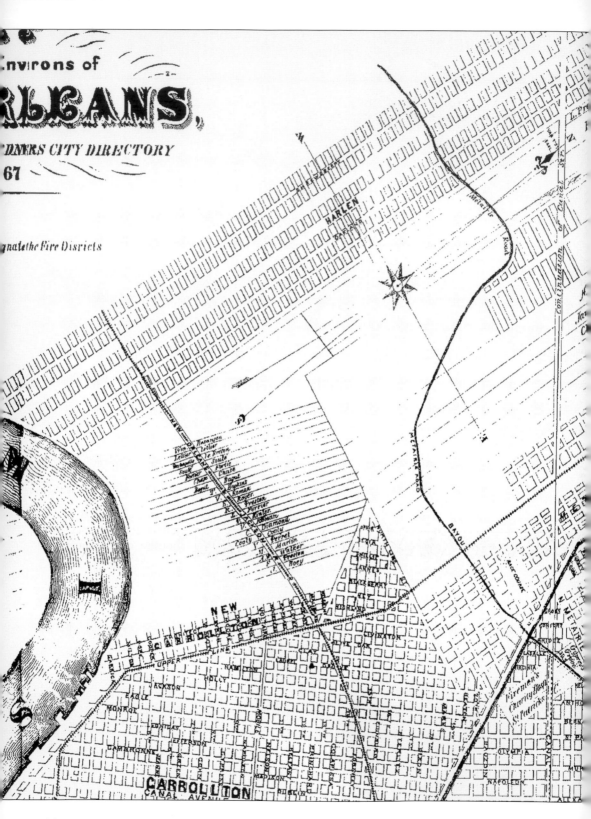

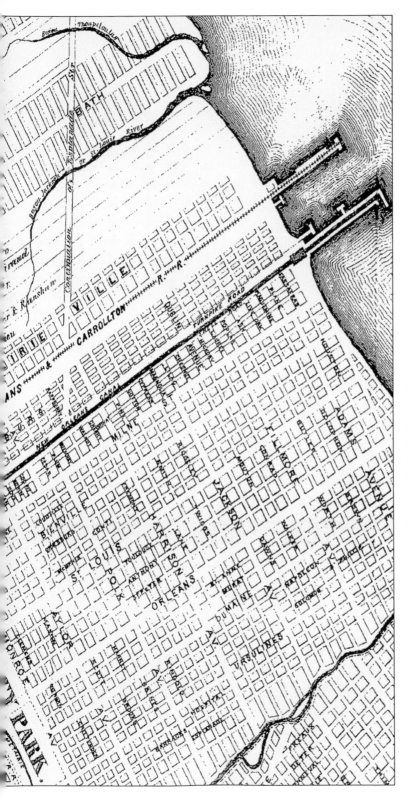

Metairie Road runs down the center of this section of a map created for an 1867 city directory. The map reveals the westward expansion of housing developments from the old city. Carrollton was, at this time, still in Jefferson Parish. Several housing developments west of the New Basin/New Orleans Canal are included: Metairieburg and Metairie Ville (both planned in the 1830s), Bath (planned in 1839), and Harlem (labeled here as Harlen). Large plots of individually owned land still remained. The two streets running from the top are the "Continuation of Canal St." and the "Continuation of Esplanade St." (LDL.)

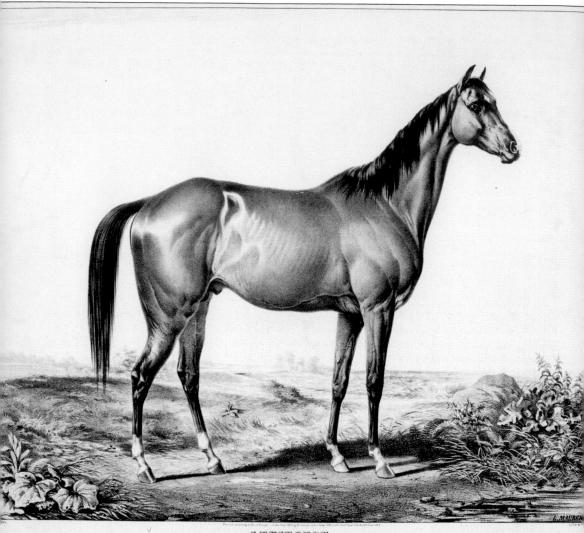

The 1855 match featuring the horses Lexington and Lecompte was such a renowned event that Currier and Ives was commissioned to design this print commemorating the race. The center text reads, "Celebrated horse Lexington (5 yrs. old) by 'Boston' out of 'Alice Carneal': Bred by Dr. Warfield, owned by R. Ten Broeck, esq. winner of the great 4 mile match for $20,000 against 'LeCompte's' time of 7:26. Over the Metairie course. New Orleans, April 2nd 1855. Won in 7:19 3/4!!!" (LC.)

METAIRIE COURSE NEW ORLEANS, APRIL, 2ND 1855.

MATCH FOR $ 20,000 LEXINGTON TO BEAT THE FASTEST TIME AT 4 MILES BEING 7:26.

R. TEN BROCK'S B. C. "LEXINGTON" BY "BOSTON" OUT OF "ALICE CARNEAL"
BY IMP. "SARPEDON" 4 YRS. 103 lbs (3 lb EXTRA) GIL PATRICK, WON.

Time of 1st mile 1: 47¼ Time of 3d mile 1: 51½
Time of 2d mile 1: 52¼ Time of 4th mile 1: 48¾

TOTAL TIME 7: 19¾.

Both of these photographs show closer views of the text on the left and right in the Currier and Ives print. About the race, Grace King wrote in *New Orleans: The Place and the People* (1926), "the grand stand, exclusive as a private ball-room, glittering with ladies in toilets from the ateliers of the great modistes. . . . and the men, from all over the South glittering too . . . The field packed, . . . and all round about, trees, fences, hedges, tops of carriages, crowded with every male being that could walk, ride, or drive from the city—that superb track of old Metairie . . . A volume would not hold it all before we even get to Lexington and Lecompte. . . . Alas! the old Metairie is expiating its sins now as a cemetery, and its patrons, its beaux and its belles and its horses—they are expiating their sins too, in cemeterial ways." Metairie Cemetery was included in the National Register of Historical Places in 1991. (LC.)

METAIRIE COURSE NEW ORLEANS, APRIL, 14TH 1855.

JOCKEY CLUB PURSE $1000, WITH INSIDE STAKE OF $2500 EACH 4 MILE HEATS.

A.L. BINGAMAN'S (R. TEN BROECK'S) B. C. "LEXINGTON" BY "BOSTON" OUT OF ALICE CARNEAL 4YRS. 103¾lbs GIL PATRICK 1:1.
T. J. WELL S'S CH. C "LECOMPTE" BY "BOSTON" OUT OF "REEL" 4YRS. 100 lbs ABE 2 D

Time of 1st mile 1: 49½ Time of 3d mile 1: 51
Time of 2nd mile 1: 51 Time of 4th mile 1: 52¼

. TOTAL TIME 7: 23¾.

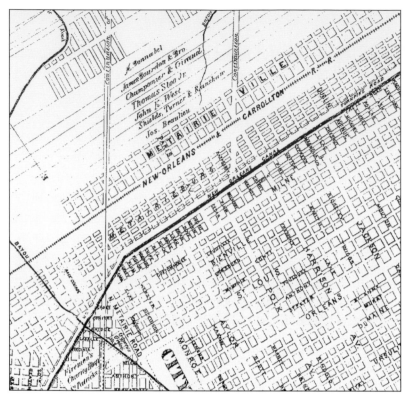

Metaireburg stretched from Lake Pontchartrain to Northline between the New Basin/New Orleans Canal and the tracks of the New Orleans and Carrollton. Metairie Ville was bordered by the tracks and the land of Joseph Beaulieu. Longue Vue House and Gardens at 7 Bamboo Road, which was built in 1925 in what was then Metairie Burg, typifies the grand homes built in this area during the early part of the 20th century. (LDL.)

On this 1893 map are two race courses. The one north of Metairie Road was the Metairie Race Course and is now Metairie Cemetery. The one below Metairie Road was the Oakland Riding Park, which became the property of the New Orleans Country Club in 1912 and was converted into a golf course. Like the cities of Carrollton, Jefferson, and Lafayette, the courses were formerly in Jefferson Parish. The current parish boundaries were set in 1874. (LDL.)

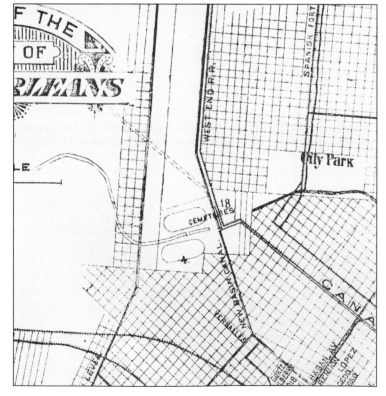

Two

BUCKTOWN, EAST END, AND WEST END

Because what we now call West End was for a time a part of Jefferson Parish, there are many historical references calling it East End (the eastern end of Jefferson). To compound the confusion, what is now Bucktown was also referred to as East End. Regardless of what it is called, the area around the Seventeenth Street Canal and the former New Basin Canal (now Pontchartrain Boulevard) at Lake Pontchartrain has long been a pleasurable venue to enjoy the water, seafood, fishing, crabbing, boating, pleasant company, and good times.

Henri Bonnabel, a French-born chemist who settled in New Orleans in 1825, acquired the tract of land between what is now Sena Drive and the Bonnabel Canal (behind property on Beverly Garden Drive), from the river to the lake. In the 1880s, he built a resort at Bucktown. A train carried resort visitors to a dock, where a ferry could be chartered to Lewisburg (near Mandeville).

Henri's son Alfred donated the land where St. Louis King of France Church and school are located. The third-generation Alfred E. Bonnabel further developed his grandfather's land into the suburbs of Bath No. 1 and Bath No. 2 (later called Bonnabel Place and Old Homestead, respectively). His wife, Luella, named the Bucktown streets for figures in Greek mythology including, among others, Phosphor (Morning Star), Aurora (Goddess of the Morning), Orion (the constellation), Helios (the Sun God), and Hesper (Evening Star).

The lovely plant-related street names Live Oak, Ash, Poplar, Chestnut, Lilac, and Rosebud took their names from the tract of land (from Metairie Road to the lake) subdivided by nurseryman and landowner Harry Papworth into the Metairie Nursery Subdivision.

Fond in the memories of older local residents are the restaurants, some on land and others on the lake, such as Sid-Mar's, Bruning's, Swanson's, Fontana's, Fitzgerald's, My-O-My, Grover's, Maggie and Smitty, Bart's, Hong Kong, Papa Roselli's, Rest-A-While, Joe Petrossi's, and the White House. They are all gone now. Hurricane Katrina destroyed the last of them: Sid-Mar's and Bruning's.

In 1859, Theodore Bruning moved his Carrollton restaurant to Bucktown/East End. With no levees, roads usually flooded in the area from September to April, so Bruning opened his doors from Easter Sunday until Labor Day of each year. In 1886, Bruning's moved to the location where it remained until Hurricane George badly damaged it in 1998. After moving to an on-land building next door, Bruning's served seafood (notably raw oysters, stuffed flounder, and soft-shelled crab) until Hurricane Katrina destroyed the West End/East End area. Bruning's was the third oldest restaurant in New Orleans (only Antoine's and Tujagues predated it). During the early 1900s, Theadore's son J. C. Bruning owned and operated the White Squadron: 42 white fishing boats (16 and 18 feet long) that he rented at 50¢ per day. For a time, Bruning's had dancing waitresses and rows of slot machines. Above is a 1949 advertisement for Bruning's Restaurant. Below is a photograph taken at Bruning's in 1949. (JPYR.)

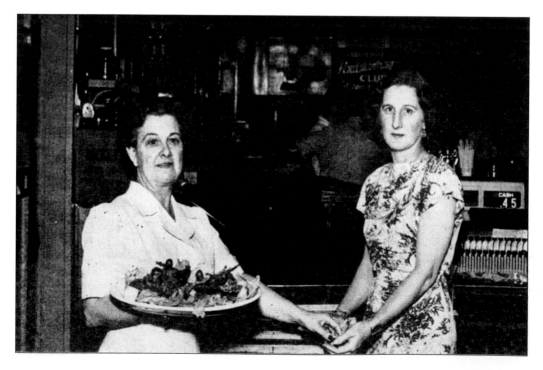

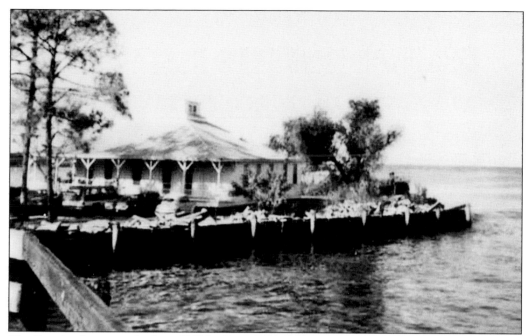

The Bruning home was built in 1893 by Capt. John C. Bruning and was a local landmark on the lake. John Bruning was credited with saving many lives while watching storms from the lookout on the roof of his house. After a 1910 fire destroyed much of the small community, he organized the volunteer fire department. He passed away in 1962 at the age of 91. (NOPL.)

By 1886, Bucktown/East End had many bars and restaurants, accessible via Carrollton Railroad and the steamer *Virginia*, which traveled to and from Mobile. Many of the current streets had been laid out. During the late 1800s and early 1900s, Bucktown was known for its gambling houses and brothels. This 1924 map section shows the streets existing in the area at that time. (LC.)

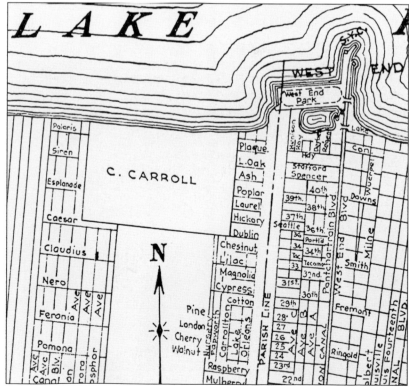

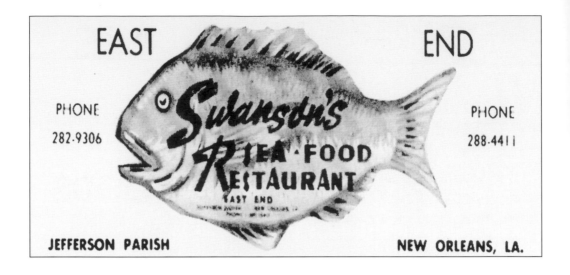

EAST END

Swanson's

Sea-Food Restaurant

EAST END

PHONE
282-9306

PHONE
288-4411

JEFFERSON PARISH **NEW ORLEANS, LA.**

Bucktown/East End was, from the beginning, a fishing village and picnic area. In later years, it was most noted for its seafood restaurants. Below, a tray full of freshly boiled crabs was destined for a table at Swanson's Seafood Restaurant in 1949. Above is a 1940s advertisement for Swanson's. (JPYR.)

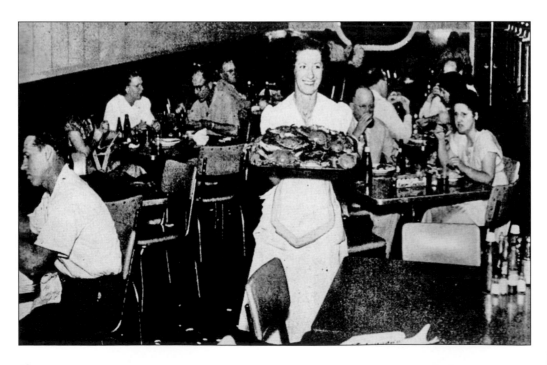

FITZGERALD'S LAKE HOUSE

AND

FITZGERALD'S SEAFOODS
(FORMERLY ROSTRUPS)

SEA FOODS A SPECIALTY

EAST END

AUdubon 9223 **JEFFERSON PARISH**

The above 1950 advertisement notes that Fitzgerald's Seafood was formerly named Rostrups. To the right, diners at Fitzgerald's enjoy seafood dinners and Regal beer in 1949. (JPYR.)

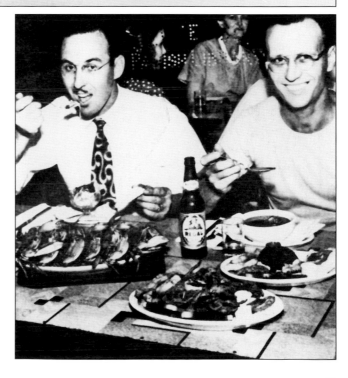

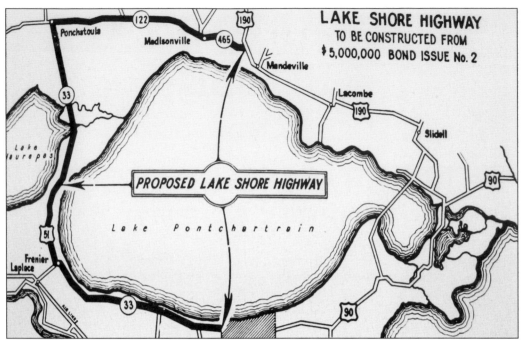

A highway along the south shore of Lake Pontchartrain from Orleans to St. Charles Parish was proposed during the 1930s. In 1955, the plan was still under consideration and included four lanes with service roads and park/play areas between the road and the lake. Other proposals included the expansion of Metairie Road to four lanes and the widening of Loumor Avenue to four lanes from the parish line to Labarre Road. None of these materialized. (JPYR.)

Here is a 1930s view of the first link (in Metairie) of the proposed New Orleans–Hammond Lakeshore Highway. Although it was never completed, the continuous erosion of this link led, by the mid-1940s, to the awareness of the need for flood protection as the area developed and expanded. (JPYR.)

44

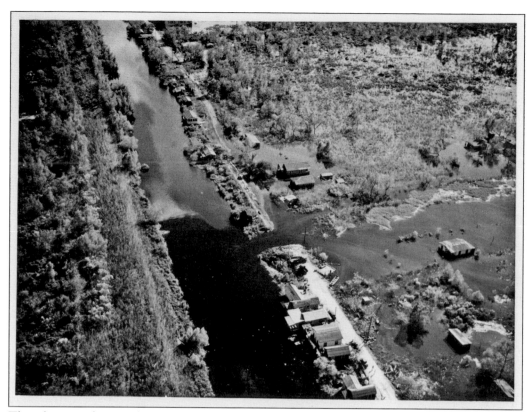

This photograph was taken by the U.S. Army Corps of Engineers on September 29, 1949, after a hurricane resulted in a breach in the Seventeenth Street Canal levee. The caption reads, "Jefferson Parish Flood—19 September 1947—The other principal gap in the 17th Street Canal levee. About one mile south of Bucktown (East End)." Several other breaks occurred on the Jefferson Parish side of the canal, causing the flooding of 30 square miles of Jefferson Parish and 9 square miles of New Orleans. (NOPL.)

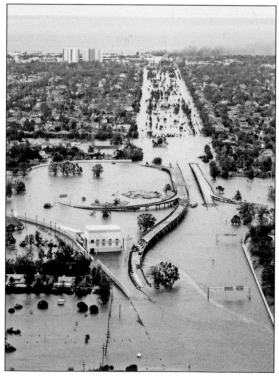

Previous East End floods resulted from an 1856 hurricane that brought six feet of water to the area, as well as floods in 1893 and 1915. Pictured is Bucktown (upper left) in the days following the 2005 break in the Seventeenth Street Canal in the aftermath of Hurricane Katrina. (U.S. Coast Guard.)

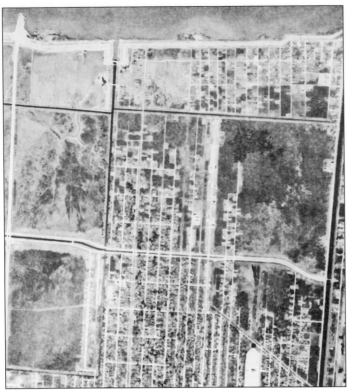

By 1949, Pumping Station No. 2 had been built at the head of the Suburban Canal, which runs between Clearview Parkway and Cleary Avenue. Efforts were underway to dredge lake sand for a 10-foot levee along the Metairie shore. This 1956 aerial view includes the Metairie lakefront, with the initial phase of the building of the Lake Pontchartrain Causeway (upper left); the toll booth area is under construction, but work on the bridge itself has not yet begun. Traces of Indian Bayou and Bayou Tchoupitoulas (the one near the lake) still remain and can be seen in the upper left quadrant. Bucktown is in the upper right corner, relatively isolated from other developed areas. (JPYR.)

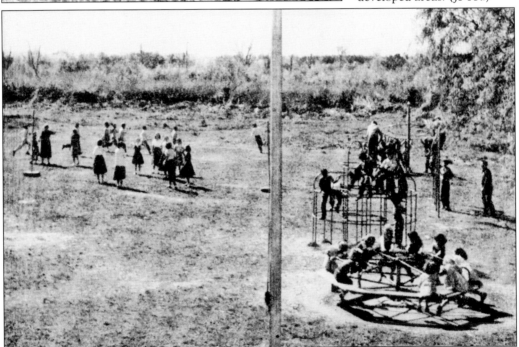

Students at the East End School play during recess in 1956, surrounded by relative wilderness. In the early 1900s, the East End School opened as a one-room schoolhouse. During the 1950s, Bucktown's Capt. J. C. Bruning served on the Jefferson Parish School Board. (JPYR.)

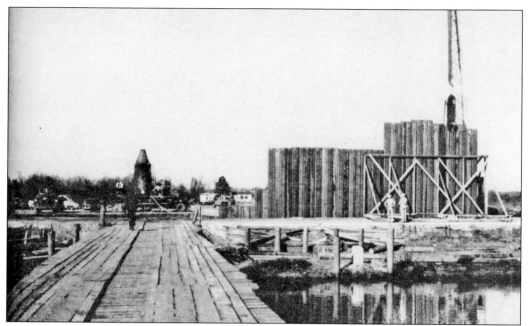

By 1917, the East End Jail had opened and remained in use until 1945. In 1927, Louisiana Power and Light brought electrical service to the folks who lived near the lake. Here workers build the bridge over the Seventeenth Street Canal in 1956. (JPYR.)

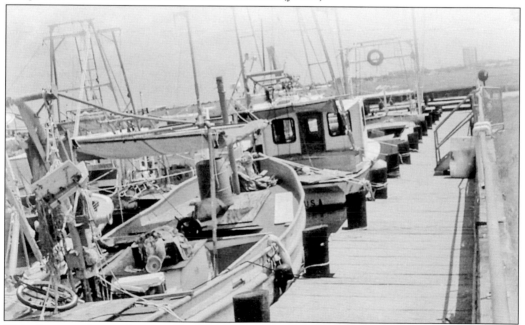

This photograph provides a pre-Katrina view of the Bucktown fishing fleet that was destroyed by the hurricane. Bucktown/East End was renowned for hunting, fishing, scrimping, crabbing, and trapping. The origin of its name is uncertain: some say it was named for the numerous bucks killed there; some recall Capt. Buck Wooley, an early settler who is said to have run a popular saloon and rented fishing boats during the 1840s; and others relate the name to the "young bucks" who frequented the area after Storyville was shut down in New Orleans. (LSUSLA.)

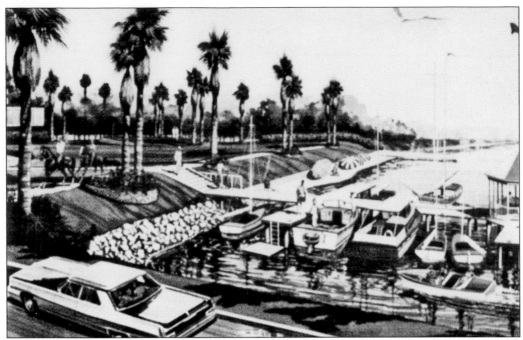

In 1966, a new marina was proposed for Bucktown. This drawing includes a park-like area with landscaping and foot paths adjacent to the docks. The plan was never completed. (JPYR.)

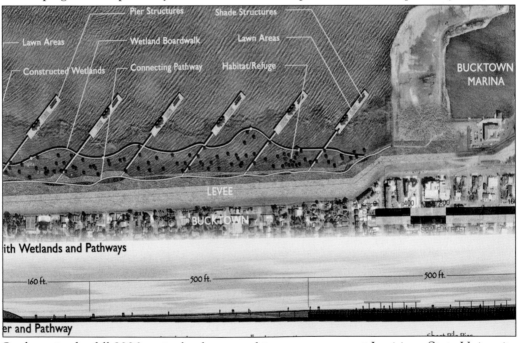

Students in the fall 2006 senior landscape architecture program at Louisiana State University proposed post–Hurricane Katrina plans for the lakeshore along Bucktown. This particular plan calls for a large expanse of pedestrian pathways and lawn areas, as well as wetlands, a habitat refuge, and a series of piers. The students' plans encompassed the area between the Bonnabel boat launch and the Seventeenth Street Canal. (LSUSLA.)

Three

OLD METAIRIE

Metairie Road was the community's first main street, dating back to ancient days. In post-modern days, it was similar in many ways to every small town's main street. Residents of Old Metairie, unlike those in many or the newer subdivisions, had easy access to goods and services along Metairie Road during the era before shopping centers sprouted up along the newer major highways.

In 1910, Metairie Road was still topped with dirt, as was Shrewsbury Road. Early-20th-century landowners, from the Seventeenth Street Canal to Shrewsbury Road (on the lakeside of Metairie Road), included the following: Earnest Paul Riviere, Peter Betz, Henry DeLimon, John Betz, John Palmisano, Alfred Bonnabel, Charles Persigo, Charles Rolling, John Bertucci, and Frank Fagot, whose store was located at what is now Bonnabel Boulevard at Metairie Road and had the first telephone in Metairie. On the riverside, large tracts were owned by Andrew Fredericks, John Vincent, Valentine Betz, Adolph Ricks, the Peters family (the Codham Tract), a group of Chinese families, Dan Newsham, Charles Root, the Marshall family, the Babin family (at Labarre Road, which included a blacksmith shop), and the Shultz family (who were said to be an opera-singing couple). Above Shrewsbury Road, plantation property still ran from the river to the lake.

Metairie Club Gardens was carved from cypress swampland in 1926. By 1937, these residential developments had been established: Athania Place, Beverly Knoll, Bonnabel Place, Brockenbraugh Court, Crestmont Park, Elmeer Place, Farnham Place, Forest Hills, Livingston Place, Metairie Terrace, Oak Ridge Park, Ridgeway Terrace, and Vincent Place. In 1938, a street-lighting district was created, and Metairie Road offered a shopping center, grocery stores, bakeries, hardware stores, restaurants, neighborhood bars, and a movie theater. In 1946, the Metairie Savings Bank and Trust Company was established.

In 1954, Bayou Metairie alongside Metairie Cemetery was filled. In 1955, the all-women Krewe of Helios was formed; the Krewe of Zeus was organized at Genarro's Restaurant and Bar. The 1960s brought the Do Drive-In to Metairie Road on a piece of land that had served as a greyhound track during the 1920s.

Metairie Road is laid out with odd-numbered addresses on the lakeside. In the following chapters, street addresses may appear in parentheses.

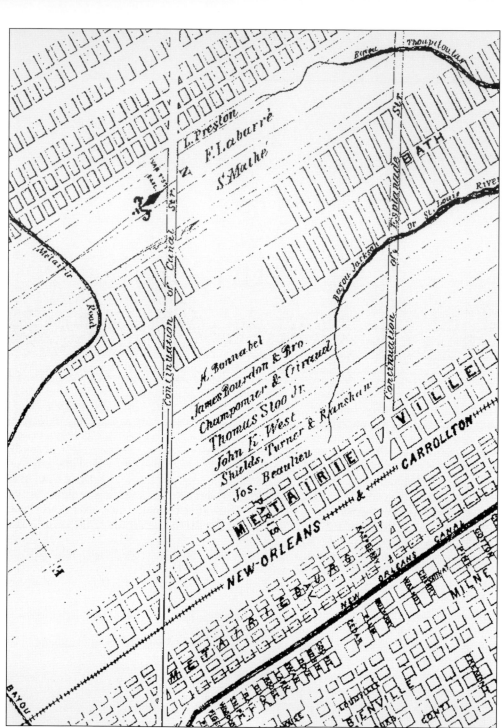

This detail from a map drawn in 1867 is labeled with the names of landowners in what is now Old Metairie. They include L. Preston; F. Labarre; S. Mathe; H. Bonnabel; James Lourdon & Bro.; Champomaer & Giraud; Thomas Sloo Jr.; John, K. West; Shields, Turner, and Ransham; and Jos. Beaulieu. Large tracts of land were still held at this time. Bonnabel and Labarre are familiar today as street names. (LDL.)

METAIRIE RIDGE

LAKE LEVEE

| 0.5 | 1.0 | 1.5 | 2.0 | 2.5 | 3.0 | 3.5 | 4.0 | 4.5 | 5.0 | 5.5 | 6.0 | 6.5 | 7.0 | 7 |

Contrary to modern folklore, most streets in metropolitan New Orleans do not lie below sea level. However, rainwater must be mechanically removed from the streets because the surrounding Lake Pontchartrain and Mississippi River tides often rise above street level. This problem is compounded by the naturally occurring and manmade levees that prevent flooding from bodies of water but also serve to trap water in the streets in the event of an overflow or heavy rainfall. Bayou Metairie also contributed to the topography, as it would (like the lake and river) regularly rise overtop its natural borders and fall, leaving deposits of soil and sand to build up over time. This diagram illustrates the situation. (LC.)

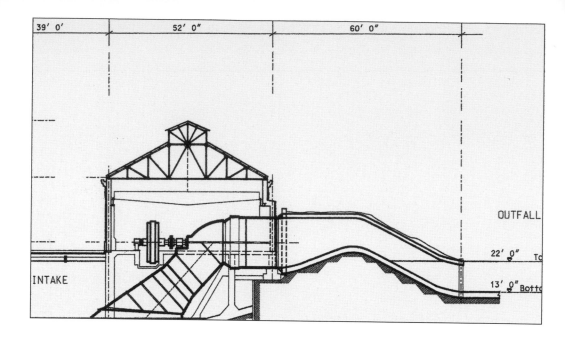

The previously mentioned condition is well exemplified at Pumping Station No. 6 on the Seventeenth Street Canal at Orpheum and Hyacinth Streets in Old Metairie. Here the pumps lift and carry water from street runoff in Metairie and New Orleans toward the lake. Station No. 6, built in 1899, holds a spot on the National Register of Historic Places. It is the oldest New Orleans–area pumping station still operating. These diagrams are from a 1992 Historic American Building Survey. (LC.)

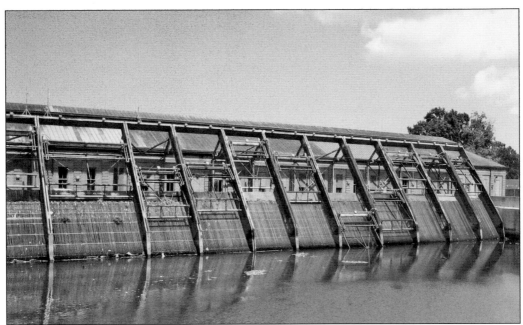

Prior to the 20th century, eight-foot-diameter steam-powered pumps served 71 miles of canals and water mains in New Orleans. They were the largest pumps used in the country. In 1900, vertical shaft screw pumps were introduced, but in 1912, New Orleans Sewerage and Water Board assistant manager Albert Baldwin Wood designed a 6-foot-diameter centrifugal pump, followed in 1913 by a 12-foot-diameter screw pump that still bears his name. It was the world's largest pump, capable of moving 200,000 gallons of water per minute. In 1914, the network of pumps moved 14 inches of rainwater in 24 hours. Pumping Station No. 6, located at the Seventeenth Street Canal, was capable of moving 9,000 cubic feet of water per second. Above is the view from the south, and below is the northern face.

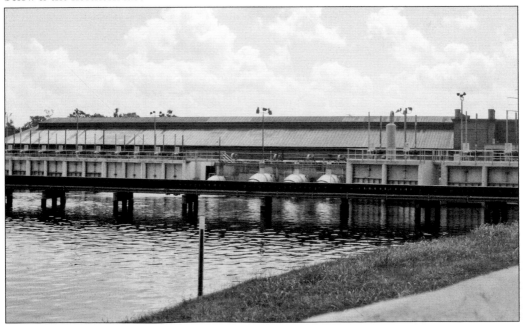

The homes above can be found on Hyacinth Street in Old Metairie within a block of the Seventeenth Street Canal and Pumping Station No. 6. They are built in the typical, New Orleans–shotgun style. By comparing these to homes on Fourth Street in the Irish Channel (below), we see that land in Old Metairie was being subdivided as early as that in many now-historic parts of New Orleans. (LC.)

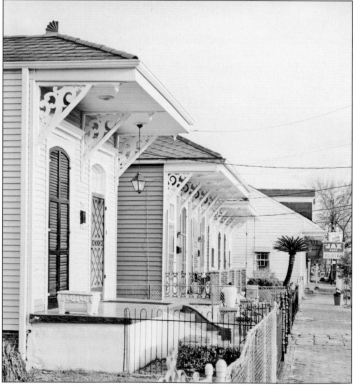

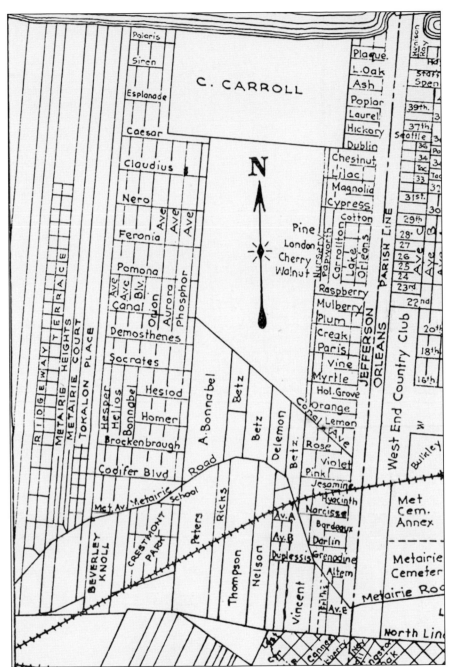

The first of Metairie's designated subdivisions is seen in this 1924 map. Metairie Ridge is unmarked here, but the streets above Metairie Road along the New Orleans/Jefferson Parish line are included. The area around the Vincent property (lower right) would become Metairie Club Gardens. The Thompson property (bottom center) would include both a miniature and a full-sized golf course. The Peters property later became Cottam Park. The Crestmont and Beverly Knoll subdivisions appear in the lower left. Bonnabel Place is unmarked, but its streets include those north of Codifer Boulevard. West of Nursery Street, in the large undeveloped area of this map, was an area known to locals as Hog Alley. (LC.)

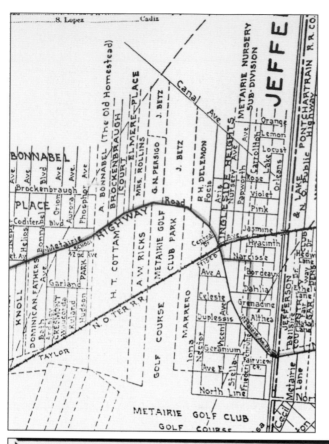

In 1916, the Napoleon Avenue streetcar line was extended from the Seventeenth Street Canal along Metairie Road to Shrewsbury Road (near Severn Avenue). It was known as the Blue Line. As had happened in New Orleans, public transportation led to new interest and growth in the Old Metairie area, and as automobiles became popular and affordable, a ride out to Metairie—long considered "the country"—became less daunting. Pictured above is a map that includes the streetcar route through Old Metairie. In 1918, the Papworth family developed the Metairie Ridge subdivision (upper right) near land used for a plant nursery; a 1954 business advertisement appears below. Streets on the Papworth property were name for fruits and flowers. Harry Papworth reportedly planted the oak trees along Metairie Road from Avenue A to Metairie's Carrollton Avenue. (Above LC; below JPYR.)

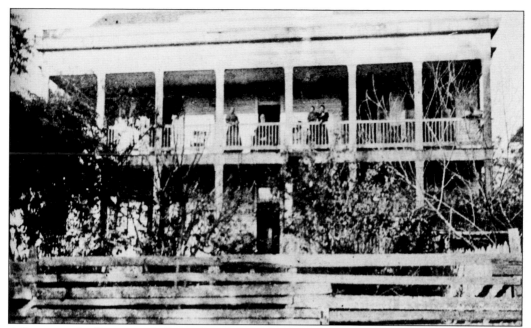

Adjacent to the Seventeenth Street Canal, Daniel Eastman owned a large piece of property where he built this imposing home (seen in 1906) on his dairy farm. Mr. and Mrs. Eastman, along with neighbors Ernest Riviere and Louis E. Breaux, were actively involved in the community, serving as officers of the Eighth Ward Democratic Club. (JPYR.)

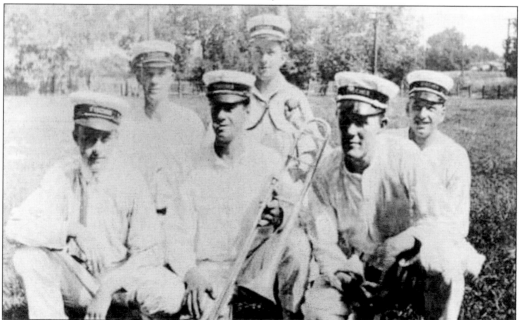

The Eastmans opened their property to the public for use as a picnic ground. Fischer's Ragtime Band are pictured here on the Eastman farm in 1915. Shown from left to right are Fred J. Williams (drums), George Barth (cornet), George "Happy" Schilling (trombone), Harry Shannon (cornet), Tony Barba (bass), John Fischer (clarinet). The Metairie Small Animal Hospital has occupied a portion of this land since 1952. (LDL.)

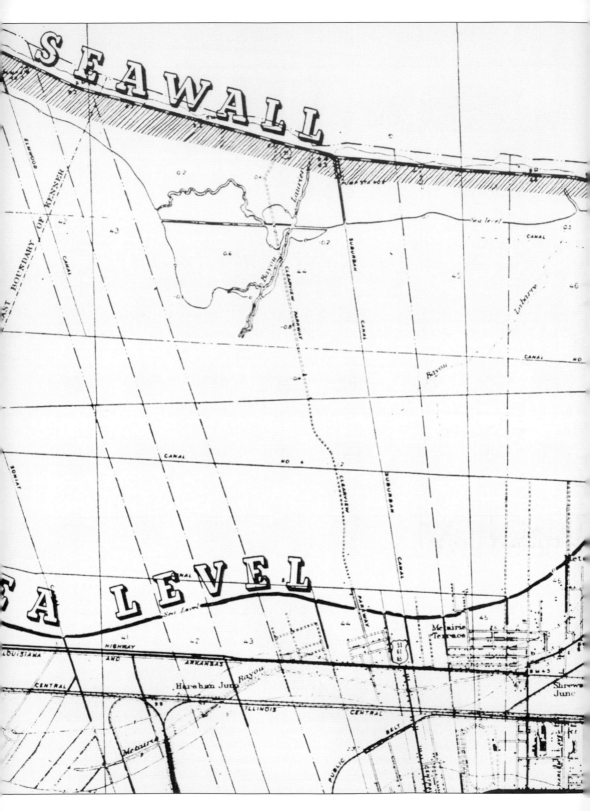

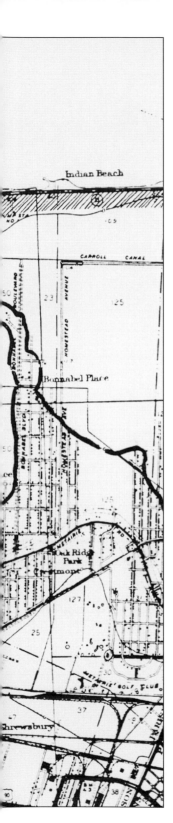

S. V. Applewhite composed this map of ground elevations during the late 1940s. By 1949, a seawall was being constructed along Metairie's lakeshore. Note that the majority of the area west of Bucktown and what we now know as Old Metairie has yet to be developed. The proposed extension of Clearview Parkway from present-day West Napoleon Avenue to the lake runs north to south just left of center. Canals running north to south include Soniat, Elmwood, Suburban (with a pumping station), Bonnabel, and Homestead. Three bayous, no longer existing, are pictured: Bayou Laurier, Bayou Labarre, and Bayou Tchoupitoulas, all flowing north to south from near the lake. The subdivisions identified on this map are Metairie Terrace, Bonnabel Place, Crestmont, and Oak Ridge Park. Metairie Club Gardens and the Metairie Golf Course can be seen near the lower right. (JPYR.)

59

The following photographs invite a stroll in memory down Metairie Road from the Orleans Parish line to Severn Avenue. In 1946, O. J. Andre owned and operated a service station at the corner of Friedriches Avenue. Just steps away at 201 Metairie Road, Rose Mary Douglas (above) discusses entries in a poster contest at Metairie Grammar School in 1950. Today teachers instruct students here at the Metairie Grammar Academy for Advanced Studies. A bit down the block, Metairie Pharmacy was located at 246 Metairie Road. In 1955, ABC Lighting offered residential and commercial fixtures in showrooms at 433. In 1952, a H. G. Hill was located at 437. Metairie Fabric Shop was at 501. Louis Kohlmeyer operated the Dixie Auto-Lec (514), which sold electrical and automobile supplies as well as bicycles, refrigerators, radios, paint, and hardware. A Metairie Bank branch was at 517. Garsaud's Grocery (below) was located at 521 when this advertisement was placed in 1949. Metairie Beauty School was at 531. This location was, for a time, Metairie Bar before it moved to the end of Metairie Road. (JPYR.)

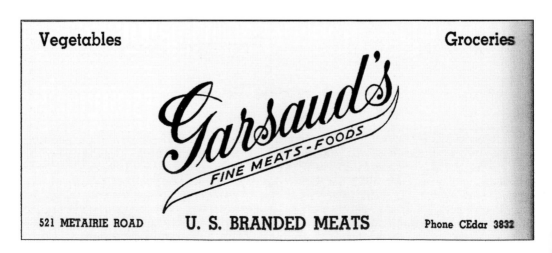

Within a block of Garsaud's, the Jefferson Bottling Company (716 Frisco Avenue) produced Hires root beer and other sodas. The business was owned by Pailet Industries, which also operated the Marada Stock Farms at the same location. In addition, Pailet ran the Metairie Ridge Ice Company, situated at 308 North Labarre Road between Metairie Road and Airline Highway. The Jefferson Bottling Company (still under Pailet ownership) is now the National Beverage Corporation, located in Harahan. This advertisement ran in 1949. (JPYR.)

Still operating at 601 Metairie Road, just across the Southern Railroad tracks (a grade separation was proposed in 1955 but never built), the Metry Café has been serving locals for decades. This advertisement was placed in 1949, but during the 1960s, Mama Mia's Italian Restaurant was located here. In the same shopping strip, Metairie Hardware and Paint Store (605 Metairie Road), owned and operated by C. P. Schexnayder, offered deliveries during the 1940s. At 609 Metairie Road was Villar and Sons Roofing Contractors, where "Villars Roofs Fool the Rain." During the 1940s, Villar offered genuine Bangor slates and Ru-Ber-Oid asbestos shingles. (JPYR.)

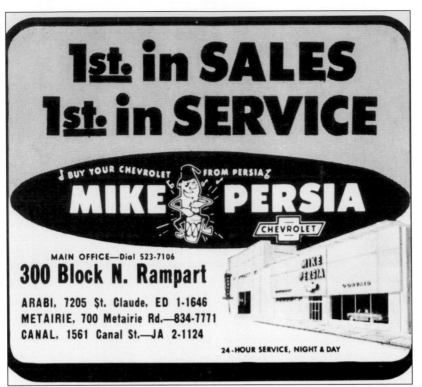

1st. in SALES
1st. in SERVICE

♪ BUY YOUR CHEVROLET FROM PERSIA ♪

MIKE PERSIA CHEVROLET

MAIN OFFICE—Dial 523-7106
300 Block N. Rampart

ARABI, 7205 St. Claude, ED 1-1646
METAIRIE, 700 Metairie Rd.—834-7771
CANAL, 1561 Canal St.—JA 2-1124

24-HOUR SERVICE, NIGHT & DAY

Many New Orleans–area residents still remember the Mike Persia Chevrolet jingle: "Buy your Chevrolet from Persia." This 1961 advertisement includes the address of the Mike Persia dealership at 700 Metairie Road. Over the years, other locations included Veterans Highway, Canal Street, North Rampart Street, and St. Claude Avenue. (JPYR.)

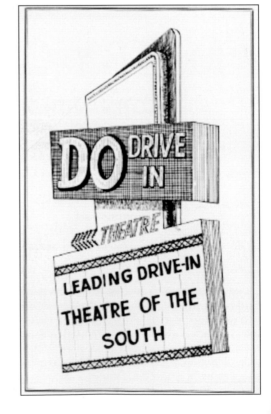

A block down the road, one could enter the Do Drive In. The Do showed its last B movie during the 1980s before it was torn down to build the upscale Old Metairie Village Shopping Center and the exclusive DeLimon Place. The condominium complex was named for Henry DeLimon, who had owned an orange grove on the property during the early 1900s. (JPYR.)

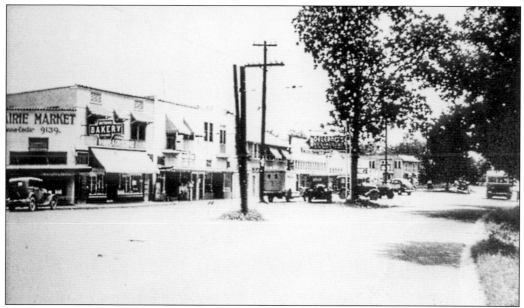

While exiting the Do Drive In on Focis Street, one passed the Metairie Employment Agency (117 Focis) and Metairie Cleaners (123). Heading back to Metairie Road, one could take a left turn onto Pink Street and stop for a delicious meal at Delerno's Restaurant (619), which specialized in crawfish dishes long before most other area restaurants served them. A sign (near the tree) on Metairie Road points the way to Delerno's in this 1937 photograph, which also shows the Metairie Market, a bakery, and Metairie Hardware. (JPYR.)

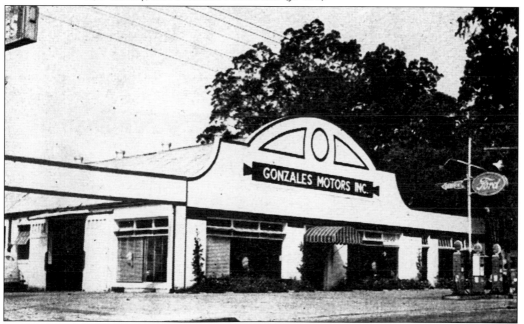

Before there was the Do Drive In, there was the Ford dealership Gonzales Motors, seen here in 1949. Located at 801 Metairie Road, the business was operated by Sidney J. Gonzales and his son Sidney Jr., as well as George B. Benoist and Acy A. Chiason. It later became Metairie Motor Sales and Metairie Ford. (JPYR.)

MASSET'S TAVERN

Sandwiches—Sea Foods

Wines—Liquor

We Deliver

Phone CEdar 9161--825 Metairie Rd.

Metairie, La.

In the same block as Gonzales Motors was Masset's Tavern, at 825 Metairie Road, offering seafood, sandwiches, wine, and liquor. This advertisement ran in 1937. John Masset was an early Old Metairie landowner. Nearby Cullotta Seafood served a complete line of fresh seafood as well as boiled crabs, stuffed crabs, boiled shrimp, and "Oysters Opened While You Wait" at 819 Metairie Road. (JPYR.)

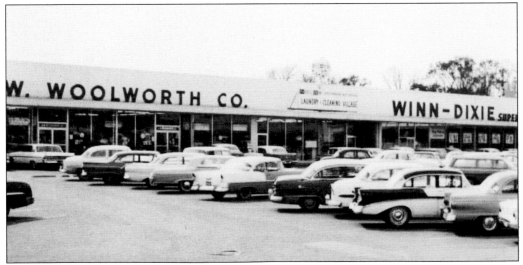

Across the road in the 800 block, a shopping center has stood for decades. This 1962 photograph provides a view of (from left to right) Woolworth's (later Katz and Besthoff and now Rite-Aid, with part of the building occupied by Pier 1), the Norge Laundry and Cleaning Village (now used by Rite-Aid), and Winn-Dixie (now Langenstein's Grocery). The complex included a McKenzie's Bakery and a Katz and Besthoff drugstore that was, at one time, near the entrance to the center (now PJ's Coffee). During the 1940s, a H. G. Hill store was situated at 806 Metairie Road. (LDL.)

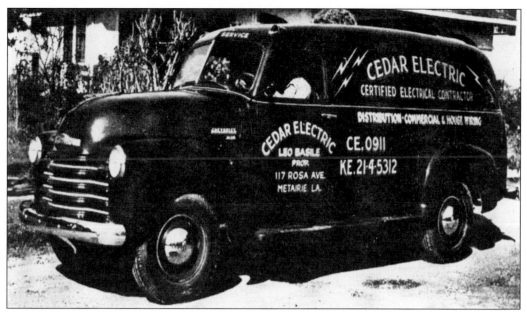

Continuing down Metairie Road, one could glance at the Cedar Electric Company, located at 117 Rosa Avenue (just off Metairie Road) when this photograph was taken in 1952. The company offered commercial and residential service. Leo A. Basile owned the business, whose motto was "Experience has no substitute—Stay Alive." (JPYR.)

Three blocks down the road, one could take a left turn at Farnham Place in 1946 for this view of New York Giants baseball great Mel Ott's home in Metairie Club Gardens—just one of many fine houses and mansions in the area. Born in Gretna in 1909, Ott played his last game in 1947 and was inducted into the Hall of Fame in 1951. In 1958, he was killed in an automobile accident at 49 years of age. He is buried in Metairie Cemetery. (JPYR.)

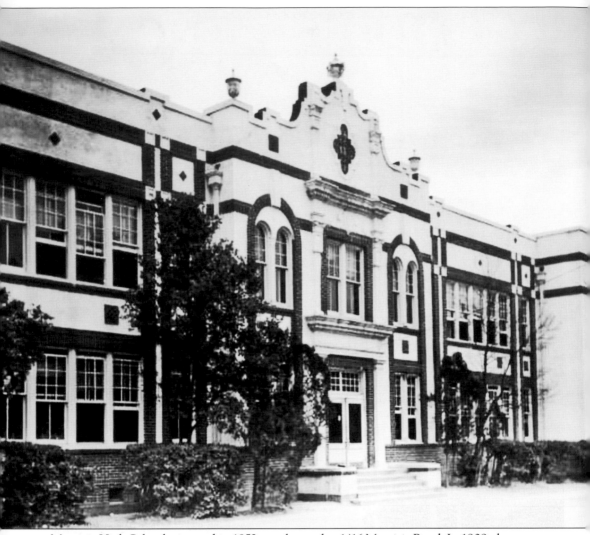

Metairie High School, pictured in 1952, was located at 1416 Metairie Road. In 1909, the one-room Metairie Ridge School opened as the first in Metairie, but by 1929, increasing enrollment had led to the building of the school shown here; it was renamed Metairie High School but included grades 1 through 12. When East Jefferson High was completed in 1955, this school was converted to Metairie Junior High under the leadership of Vernon C. Haynes. This building was demolished in 1968 to allow for the current structures. Through the years, it has been named Metairie Middle School (1969), Vernon C. Haynes Middle School (1974), Vernon C. and Gilda P. Haynes Middle School (1995), the Middle School for Advanced Studies (2004), and Haynes Academy for Advanced Studies (2006). No matter the name, many students enjoyed a cold, after-school root beer at the Frostop Drive-In across the street or broasted chicken at the Holiday Drive-In Restaurant (1425 Metairie Road). The shopping strip in the 1500 block included a National grocery store (later Zara's and now Canseco's grocers) and a Kopper Kitchen. (JPYR.)

CODIFER, INC.

Developers of BONNABEL PLACE

Pioneer Developers of METAIRIE

1905 METAIRIE ROAD

Codifer, Inc., the company that developed the Bonnabel Place subdivision, had offices at 1905 Metairie Road between Bonnabel Boulevard and Helios Avenue during the 1950s. Alfred Bonnabel created the subdivision from land (the Bonnabel Plantation) he had inherited from his father, Henri Bonnabel. Bonnabel Place, first planned in 1914, is bounded by Metairie Road, Lake Pontchartrain, Hesper Avenue, and Homestead Avenue. (JPYR.)

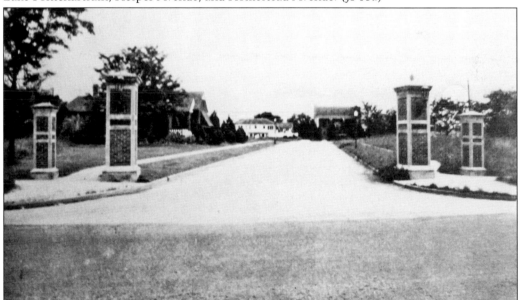

A one-room schoolhouse reportedly once stood at what is now Livingston Place (whose entrance is seen in this 1937 photograph) and was used on Sundays by the Sisters from St. Mary's Italian Parish for teaching catechism. Today Livingston Place is among the most valuable real estate in Metairie. (JPYR.)

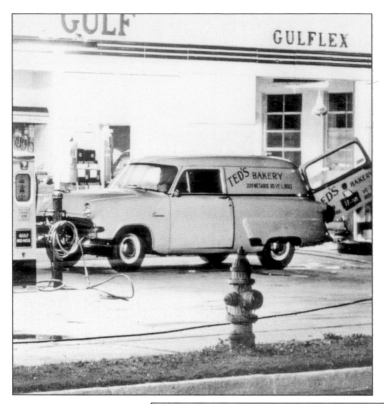

Seen here in 1956 is the delivery station wagon for Ted's Bakery (2019 Metairie Road), located in the same strip as an H. G. Hill (later the Owl Food Store at 2031). Ted's was later named Metairie Bakery and is now a clothing consignment store. Also in the 2000 block were the Kit Kat Restaurant (now Oscar's) at 2027, the TV and Hobby Store (later Vaquero's Restaurant) at 2037, and the Grand Theater (now the Little Red School House) at 2055 Metairie Road. (LDL.)

As a stop along the Old Metairie St. Patrick's Day parade route, Pat Gillen's Bar was a popular destination that stayed busy year round. This advertisement is from the 1957 Jefferson Parish Yearly Review. Pat's Bar was the same shopping strip as the Metairie Tune Up Center (2010), Chocolate Soup (a children's clothing store), and a branch of the National Bank of Commerce. These were demolished during the 1990s to make way for an AmSouth Bank branch. (JPYR.)

PATS BARS

NO. 1
1715 JEFFERSON HWY.

NO. 2
2024 METAIRIE ROAD

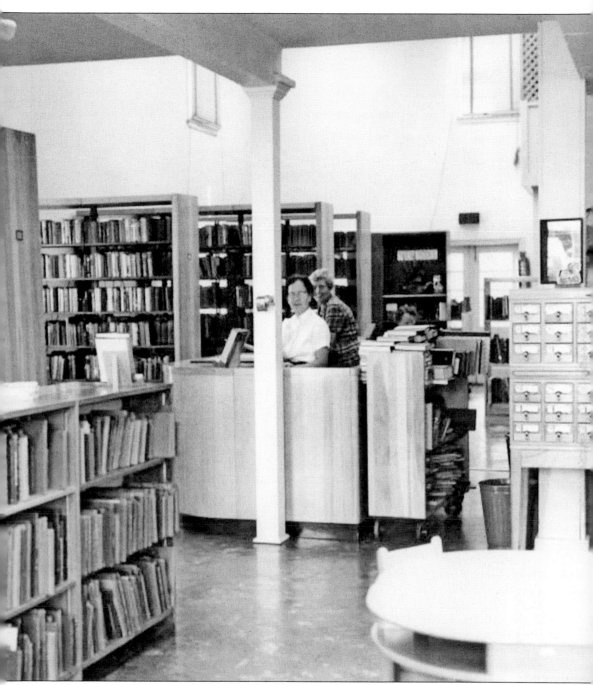

Marion Stewart (seated) and Lilian Adams (standing) worked at the Metairie Road branch of the Jefferson Parish Library when they posed for this 1940s photograph. After the library moved down the road to a new building in the 1980s, the Arts and Crafts–style building at the corner of Atherton Drive was converted into an art center, then a sign company, and now a children's clothing store. (LDL.)

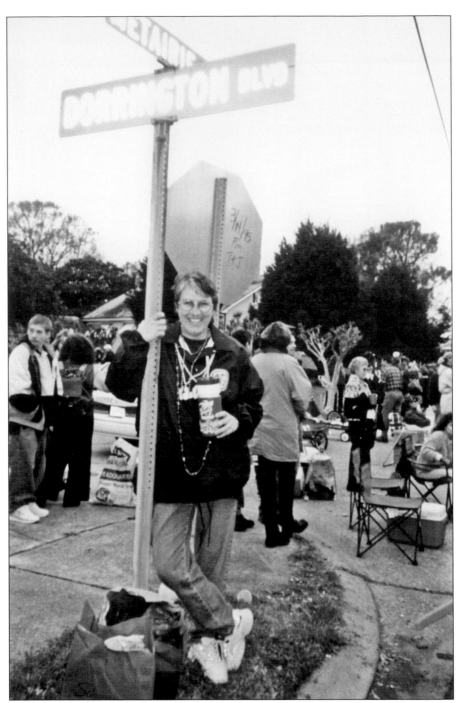

Dolly Tripp Breaux holds up the street signs on Dorrington Boulevard at Metairie Road while awaiting the arrival of Renee Borne in the 1999 St. Patrick's Day Parade, an event which has rolled along the same route from Severn Avenue since 1971. The parade was conceived by the gang at Fulco's Bar (519 North Turnbull Drive), which had been for years the staging ground for the Jefferson Unified Marching Association (JUMA). Breaux grew up on Dorrington Boulevard. Gail Nebel stands in the back center.

Heading down the street, one could see Andrew Azzarello sitting atop a land turtle he discovered in his yard in 1990. His home is in the Beverly Knoll section of Old Metairie, which was laid out during the early 1920s. Gov. Dave Treen once owned a house on the street. Clarence Foret was famous for his beautiful rose and vegetable gardens at the corner of Metairie Road. Saints player Chris Naoli also lived on the street.

Continuing down Dorrington, one could return to Metairie Road via Dolores Avenue, which leads to Glendale Gate. There the newer Metairie branch of the Jefferson Parish Library can be found. Across the street one would see, in 1965, the Gulf Service Station in the 2300 block at Metairie Heights Avenue. Many Metairie brides bought their gowns and accessories at the neighboring Winderella's Bridal Service (2325), which offered "Everything for the Bride and Her Party." (LDL.)

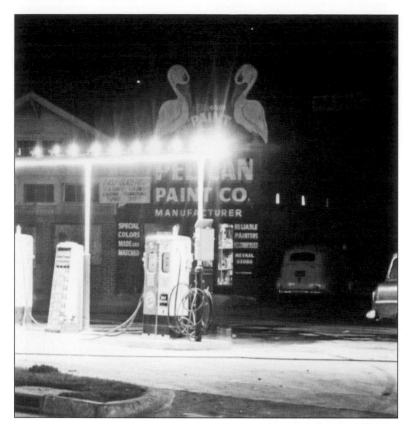

Beyond the service station was the Pelican Paints and Shingle Stains Company, which manufactured products at 106 Metairie Heights Avenue. Pelican Paints offered painting services as well as its retail outlet. This building now houses the unofficial Jefferson Parish Museum. The adjoining building is now an art supply shop. (LDL.)

The historical marker at the corner of Labarre Drive and Metairie Road gives a brief history of the family that once owned the surrounding land. Bayou Labarre, which flowed between present-day Clearview Parkway and Causeway Boulevards near the lake, was also named for the family. No streets cross Metairie Road with the same name except Frisco (which runs along the western side of the railroad tracks on the lakeside of Metairie Road but switches to the Eastern side of the tracks on the river side of the road) and Orpheum Avenue (along the Seventeenth Street Canal). Labarre Drive switches its name to North Labarre Road south of Metairie Road.

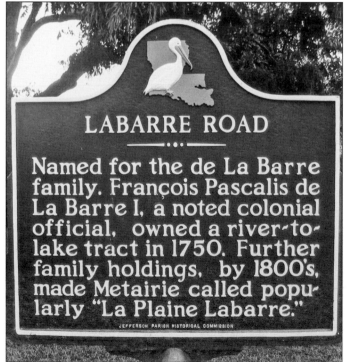

LABARRE ROAD

Named for the de La Barre family. François Pascalis de La Barre I, a noted colonial official, owned a river-to-lake tract in 1750. Further family holdings, by 1800's, made Metairie called popularly "La Plaine Labarre."

JEFFERSON PARISH HISTORICAL COMMISSION

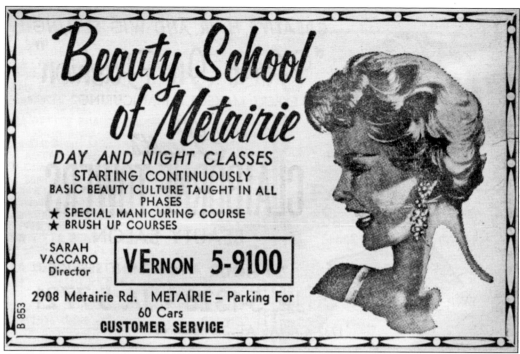

A block down was the Beauty School of Metairie (2908 Metairie Road), which offered day and night classes under the direction of Sarah Vaccaro in 1965.

Since 1885, the Muhleisen family has served the New Orleans area and still operate this funeral home a block east of Labarre at 2929 Metairie Road. During the 1960s; Muhleisens provided a 24-hour citywide ambulance service and were designated the "Official Funeral Directors for the Parish of Jefferson." Across the street from Muhleisen's was the East Jefferson Business Telephone office, but most everyone simply called it "the Phone Company Building."

What is now Barreca's Restaurant, at 3100 Metairie Road, was Ovella's when this advertisement ran in 1976. The casual neighborhood restaurant offered simple, traditional New Orleans fare such as po-boys and seafood. It was owned and operated by Bobbie and Jerome Sauer. (JPYR.)

Just after going under the Causeway overpass, one comes upon Genarro's Restaurant and Bar at 3206 Metairie Road. In 1976, proprietor William J. Dwyer, a former Jefferson Parish councilman and Louisiana state representative, proclaimed it to be the "oldest bar in Metairie operated by the same family." Members of the Dwyer family are shown here in 1945. During the 1950s, an orchestra played for dancers on Friday and Saturday evenings. Dwyer claimed that Metairie's carnival Krewe of Zeus was organized at his bar and that it was visited by many famous personalities. A one-block street, Gennaro Place, runs alongside the bar/restaurant. (JPYR.)

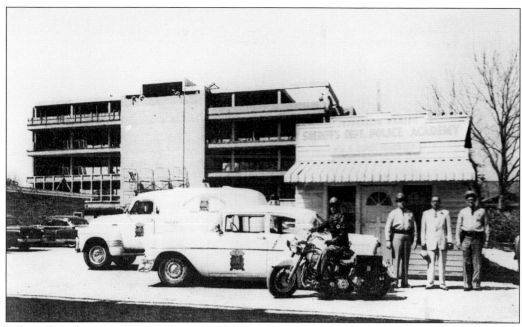

When this photograph was taken in 1957, the Sheriff's Department Police Academy had just moved to its new location between Metairie Road, Airline Highway, and Causeway Boulevard. In the back, construction work can be seen on the East Bank parish office building at 3300 Metairie Road. The building was demolished during the 1990s. Across the street at 3301, the Metairie Blue Line service harkened back to the days when a streetcar traveled Metairie Road from end to end. (JPYR.)

This view, taken from Metairie Road, shows the East Bank parish office building in 1962. These parade stands were provided for special needs children by the Krewe of Zeus—the oldest parading organization in Jefferson Parish and the first to offer night parades (always the night before Carnival Day) in the suburbs. Organized in 1957, Zeus presented its first parade in 1958, one that honored the New Orleans tradition of a mule-drawn king's float. The organization first paraded on Metairie Road but moved to Veterans Highway until 2007, when, for its 50th anniversary, it returned for one night to the original route. (LDL.)

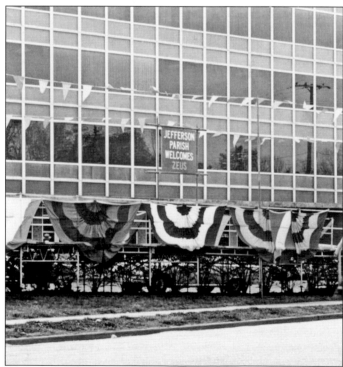

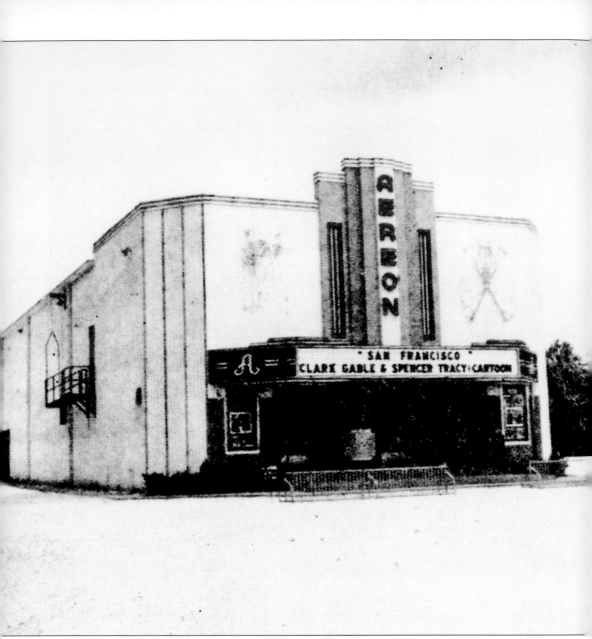

The Aereon Theater, built in 1948, was located on Metairie Road near Severn Avenue. The 1949 marquis reads, "San Francisco—Clark Gable & Spencer Tracy & Cartoon." Metairie Road once boasted two neighborhood theaters, the other being the Grand at the corner of Beverly Garden Drive. (JPYR.)

Opened in 1945, Zummo's Super Market still operates today, serving delicious po-boys from its deli. In this 1960s view, ham is being sold for 59¢ per pound, bacon for 29¢, and sirloin for 89¢. (LDL.)

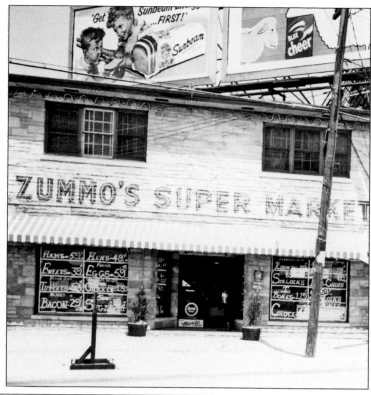

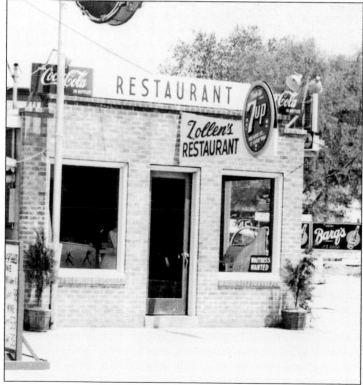

Zollen's Restaurant, pictured in the 1960s, stood next door to Zummo's. Note the vintage signs for Coca-Cola and 7-Up. To the right are a Barq's sign and a Merita Bread sign that advertised its Severn Avenue outlet. (LDL.)

Zummo's can be seen on the far left of this 1954 photograph, taken from the corner of Severn Avenue/Shrewsbury Road at Airline Highway. The sign on the far right points to the Aereon Theater. (LDL.)

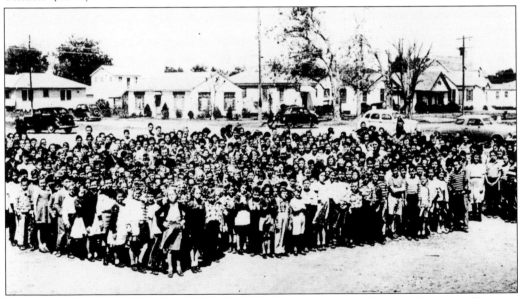

A block before ending at Severn Avenue, Metairie Road seems to split as westbound traffic veers to the north. Actually only eastbound traffic is allowed within this block; westbound vehicles drive along Johnson Street before reaching Severn, and when they do, they pass the side of Ella Delhonde Elementary School (219 Severn Avenue). Here students spend some time outdoors after a fire drill in 1949. By 1951, Metairie's student population had grown, requiring additions to the Deckbar School, Ella Delhonde, Metairie Grammar, and the East End School in Bucktown. Bridgedale School was under construction that year. (JPYR.)

Four

AIRLINE HIGHWAY

There were no airlines along the road when it was constructed during the 1930s under Gov. Huey P. Long's administration, but local lore speaks of Governor Long commissioning Airline Highway so that he would be able to travel more quickly to New Orleans, a city whose pleasures he enjoyed. Airline Highway was the first modern highway in the New Orleans area and the first major traffic artery through Metairie running in an unbending route; Metairie Road followed the winding high ridge of the ancient Bayou Metairie and the pre-existing Jefferson Highway, and River Road followed the meandering path of the Mississippi River after it deposited a natural levee that allowed for flood-free transportation via automobile.

Airline Highway was dominated by motels, restaurants, and bars. Motels and tourist courts served the needs of visitors to New Orleans in the era when automobiles first allowed middle-class families to vacation away from home. A motel room on Airline Highway was just minutes away from the city, but the prices were much lower. During its heyday as a vacation destination, the highway offered—for the most part—clean, safe rooms at affordable prices.

Along the 7-mile stretch between New Orleans and Kenner, Metairie's Airline Highway hosted the first outlet of a major New Orleans department store that would become a regional chain, as well as the first local franchise of a national fast food outlet. It included four bowling alleys, two drive-in theaters, two cemeteries, a public incinerator, a motel facility that allowed guests to "Sleep in a Wigwam," a motel in which an evangelist did not sleep; a golf-playing chicken; and a major organized crime figure's headquarters. A bank and a bar were used as jails.

Renamed Airline Drive in an effort to impart an air of dignity to a highway that had seen better days, Metairie's second oldest major artery has been somewhat revitalized in recent years with the addition of the New Orleans Saints training camp, the AAA Zephyr baseball field, and La Salle Park.

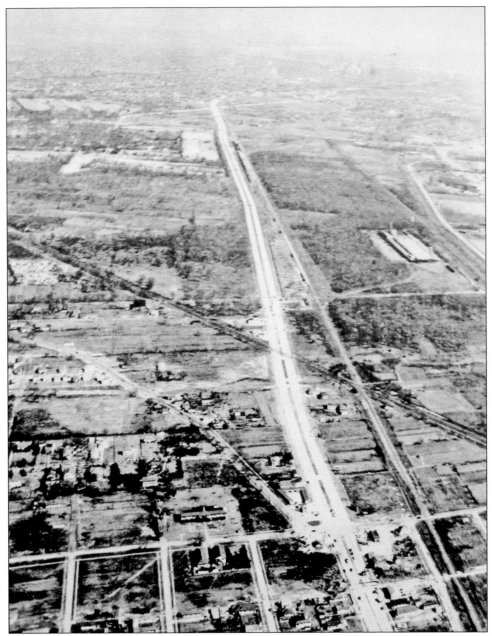

Airline Highway runs down the center of this photograph while Ella Delhonde School can be seen at the lower left of center. Shrewsbury Road continues where Severn Avenue ends at the intersection of Airline Highway. Metairie Road runs diagonally from Severn near the highway to the left center edge. Airline Highway closely parallels the original tracks of the Louisiana Railway and Navigation Company. The intersecting tracks are of the New Orleans Terminal Railroad. Industrial interests, for the most part, lined the riverside of the highway (right) with many businesses relying on the railroads to ship products and goods. Much is undeveloped in this 1941 photograph, but the area would soon boom. At the New Orleans/Metairie boundary at the Seventeenth Street Canal, street numbers along Airline Highway begin at 100. Like Metairie Road, the odd-numbered addresses are on the lakeside. (JPYR.)

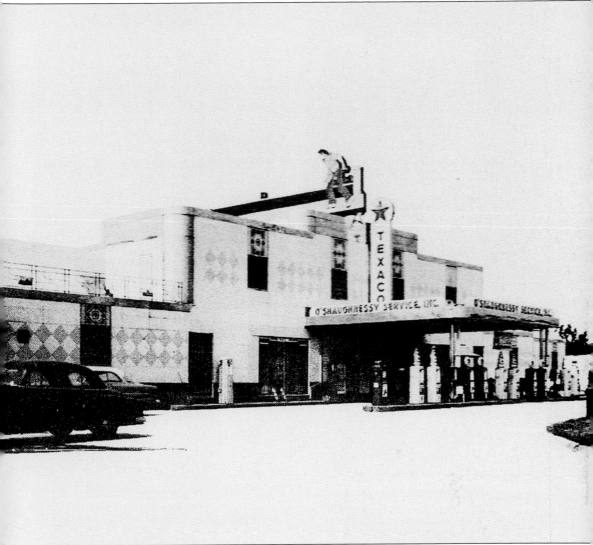

One of the childhood delights of riding down Airline Highway to the Orleans Parish line after dark was viewing O'Shaughnessy's fantastic neon sign depicting a bowler in action, perpetually scoring a strike. O'Shaughnessy, at 101 Airline Highway, offered 40 air-conditioned alleys as well as billiard tables, food and drink, and an automobile service station. This photograph was taken in 1957. The property is now the location of a bottled water company. (JPYR.)

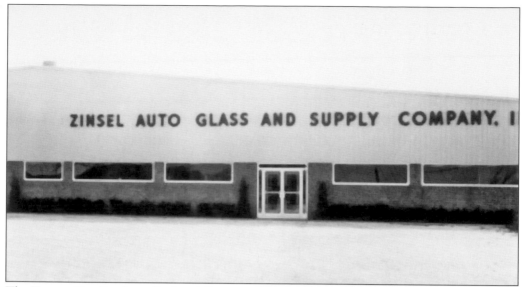

The Kansas City Southern Railroad Company has, for decades, occupied the long stretch along the riverside of Airline Highway in Metairie from the parish line to Maple Ridge Drive, with the exception of Zinsel Auto Glass Company at 612 Airline Drive, which has been in business at that site since the mid-1900s. (LDL.)

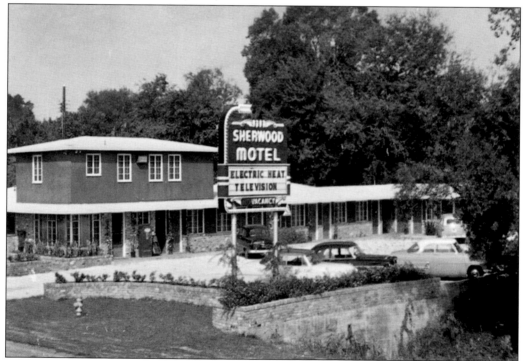

On the lakeside of the highway, along much of this same area, a fence runs at the border of the golf course of the Metairie Country Club. In the past, this stretch of road was lined with motels and a few businesses. The Sherwood Motel, pictured in 1957, stood at 1015 Airline, and the Country Club Motel was nearby at 1035. In the following block, the SSS Restaurant and Bar served steaks cut to order and provided private rooms for parties and receptions at 1101 Airline Highway.

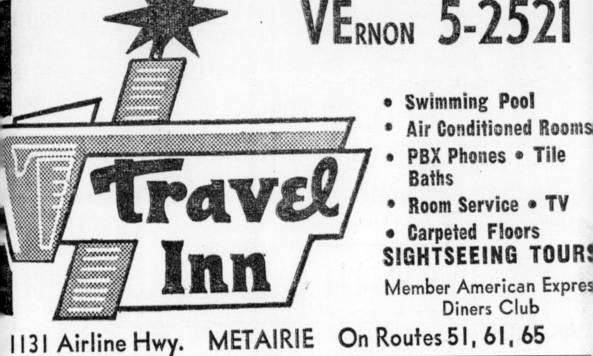

At 1131 Airline Highway, the Travel Inn offered many modern amenities during its heyday in the 1960s, including a free reservations service via teletype and PBX phones. The rooms were carpeted and air-conditioned, and room service was available. By the late 1980s, however, it had devolved into a seedy, hourly-rate motel. Here in 1988, in close proximity to the high-class Metairie Country Club property, Jimmy Swaggart ended his reign as a popular and lucrative televangelist when rival evangelist Marvin Gorman arranged for photographs to be taken of him involved in illicit activity. Swaggart confessed, appealed for forgiveness, and was defrocked. The motel has since been demolished.

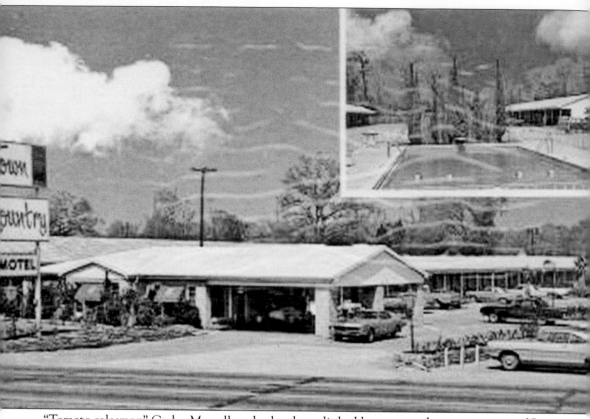

"Tomato salesman" Carlos Marcello, who has been linked by some to the assassination of Pres. John F. Kennedy, handled much of his business from offices at the 100-unit Town and Country Motel (1225 Airline Highway), which he owned in 1965 when this postcard was mailed. Just down the road, the Tulane Motel (1325), owned by Hosea Lafleur, offered "A Home Away From Home" with 50 modern rooms and suites, steam heat, free continental breakfast, an adjacent restaurant, and sightseeing tours. The Chestmar, just past Beresford Drive at 1395 Airline, was the last in this stretch of motels whose properties have become the high-end Metairie Club Estate subdivision.

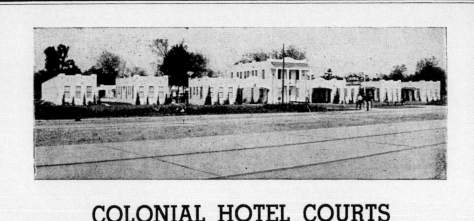

COLONIAL HOTEL COURTS

1500 Airline Highway

New Orleans

Phone CEdar 3600

New Orleans 20, La.

During the 1960s, a Royal Castle served tiny burgers on the corner of Maple Ridge Drive at 1401 Airline Highway. Its commissary and regional offices were next door at 1405. Across the road at 1500 Airline Highway, between Maple Ridge and Ridgewood Drives, the Colonial Hotel Courts (pictured in 1941) welcomed guests under the proprietorship of C. Henritzy. (JPYR.)

In 1949, the Borden Company built a Colonial-style office and retail outlet (seen here in 1954) and a large processing plant at 1751 Airline Highway (near Ridgewood Drive) at a cost of $600,000. From there, Borden packaged milk, cream, cottage cheese, yogurt, and ice cream and distributed the products throughout the greater New Orleans area with its fleet of mobile vehicles (costing $250,000) during an era when milkmen made their daily runs. (JPYR.)

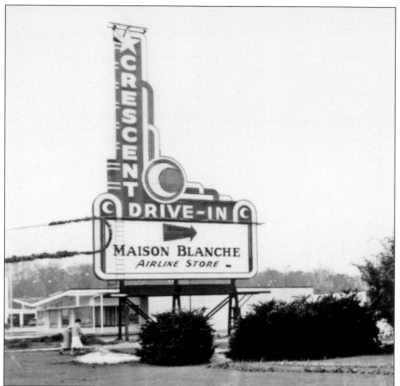

The Crescent Drive-In Theater was named for the Crescent Airline Shopping Center, whose complex included the land it occupied at 1761 Airline Highway. The drive-in shared its marquee in this 1956 photograph with Maison Blanche department store. The other Metairie drive-ins were the Airline near Cleary Avenue, the Do on Metairie Road, and the Westgate on Veterans Highway. (LDL.)

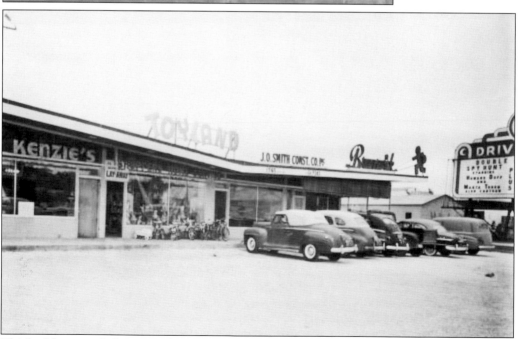

This building stood close to Airline Highway in the 1700 block, in front of the Crescent Drive-In. It housed McKenzie's Pastry Shoppe, Toy Land, the J. D. Smith Construction Company, and a Brunswick bowling supply outlet. Note the drive-in sign on the right. The 1950 movie Spyhunt, starring Howard Duff and Märta Torén, was on the bill. (LDL.)

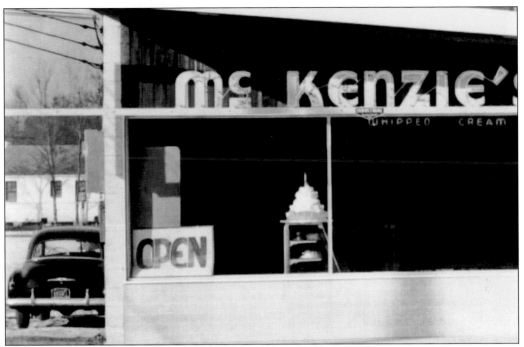

A closer view of McKenzie's Pastry Shop reveals a wedding cake in the window. McKenzie's was beloved by many New Orleans–area residents for its Buttermilk Drops, Pineapple Delight Cake, Black-out Cakes, cinnamon rolls, brownies, shoe soles, petite fores, turtles, and king cakes, among other delicacies. (LDL.)

Yet another motel, this one at 1781 Airline Highway, was called the Alline Tourist Court, but what sets it apart is its view of the side of the Crescent Drive-In screen, visible to the right of center in this 1941 photograph. In the next block, at 1801, a branch of the local Buck Forty-Nine Steak House offered a 10-ounce steak, baked potato, and salad for $1.49 in addition to seafood, pancakes, and 27 varieties of waffles. (LDL.)

Located at 1901 Airline Highway, Maison Blanche department store was a major draw to the Crescent Airline Shopping Center. From its beginning in 1898 on Canal Street, the store grew into a regional chain. It was founded by German-born Isidore Newman, a business man and philanthropist whose donation to establish a Jewish orphans' home in 1856 evolved into the exclusive Isidore Newman School in uptown New Orleans. This photograph was taken in 1956, the year the shopping center was built. (LDL.)

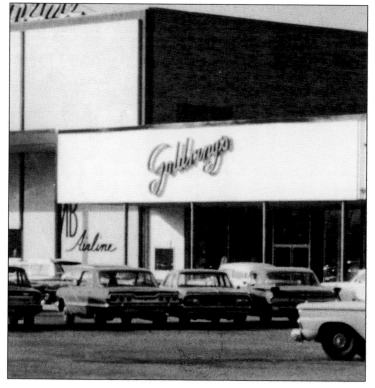

Maison Blanche's next-door neighbor at the Crescent Airline Shopping Center was Goldring's—another Canal Street store that, for the first time, expanded with a location in Metairie. It is pictured here in 1967. The center also included Walgreens, Hobbyville, the Harem cocktail lounge, Imperial East Gifts, Thom McAn shoes, My Shop, Mayfair of New Orleans, Baker's, and the National Shirt Shop. (LDL.)

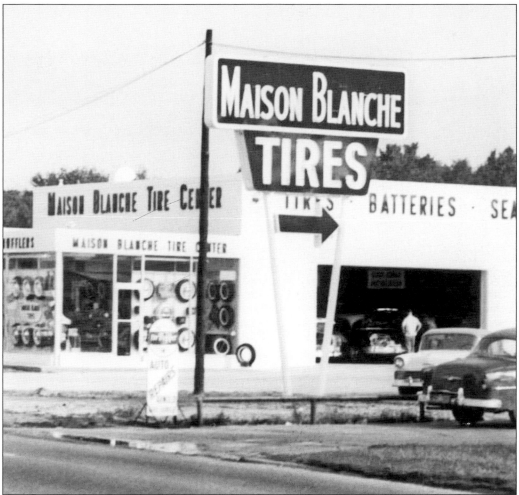

This 1960 view shows the Maison Blanch Tire Center. The nearby Villa Motel touted telephones, televisions, air-conditioned rooms, and tours at 1929 Airline. The Bacon Lumber Company was located at 2400 (now an empty lot), and the Capri Quality Courts Motel stood at 2410 Airline (now Advance Auto Parts). (LDL.)

In 1951, Schwegmann's invited all who had not done so to "Follow the Crowds to the Store That Has the Lowest Prices in Town" at its first suburban location on Airline Highway (2701) at Labarre Road. It offered a unique (to Metairie) experience where one could grab an oyster loaf and a beer at Shopper's Bar to carry down the aisles while making groceries. (JPYR.)

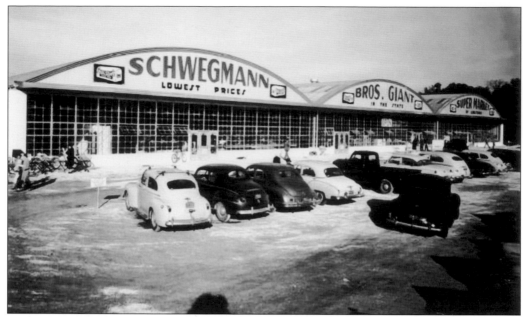

The cavernous Schwegmann's was not air-conditioned when this photograph was taken in 1950, but it was fronted with windows and topped with large roofing vents above its unfinished ceiling. Across the front, under the "Schwegmann Bros. Giant Super Market" logo, was written "LOWEST PRICES IN THE STATE OF LOUISIANA." Brothers John, Anthony, and Paul Schwegmann owned the store. (LDL.)

John Gerald Schwegmann. Jr. (left) and two unidentified men pose near some frozen pot pies at the Airline store in 1950. The original Schwegmann's Grocery and Bar was founded in 1869 at the corner of Piety and Burgundy Streets in the Ninth Ward of New Orleans. The German-born founder's grandson was born above the store in 1911. He began working there full-time in 1939. By 1946, he and his brothers had opened the first Schwegmann Brothers Giant Super Market on St. Claude Avenue near Elysian Fields. (LDL.)

With the introduction of the "Giant Super Market" concept, New Orleanians were offered a Wal-Mart-style store long before "big box" stores became widely popular. Schwegmann's sold not only groceries but offered fishing gear, sporting goods, bars, raw oyster bars, school uniforms, toys, fresh baked goods, liquor (including Old Piety and Burgundy whiskey), jewelry, clothing, and more. This diversity of products is illustrated in this photograph showing the large liquor department, as well as the fresh flower selection to the right of center. (LDL.)

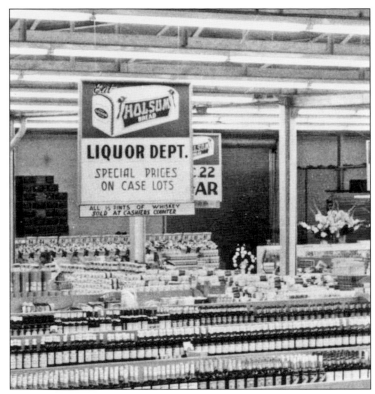

Schwegmann's often ran special promotions such as the introduction of the local Dixiana Bakery's new Melt-O-Way coffee cake. Here a model sits atop a display case while a Schwegmann's employee looks on. The store's paper grocery bags routinely touted local politicians prior to elections; John G., his son John F., and his daughter-in-law Melinda all held public offices. (LDL.)

A close-up view of the Airline store in 1950 reveals that Schwegmann's offered cut-rate prices on television sets and electrical appliances. It also had a large record department that sold "all kinds, all speeds, all makes," including rhythm and blues and "hillbilly." (LDL.)

Schwegmann's was the first grocery store in New Orleans to offer self-service shopping. Initially customers could opt for full-service or self-service, with a 10-percent discount to self-servers. The lower prices made Schwegmann's very popular but also drove many smaller grocers out of business. At its peak, the chain included 46 locations. The business was sold in 1996. (LDL.)

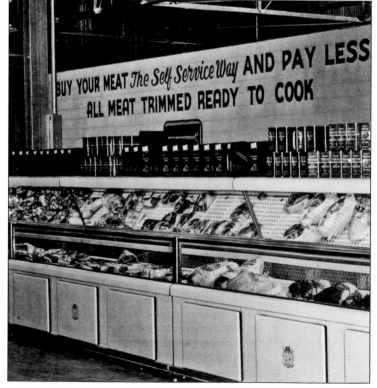

In the 2800 block of Airline Highway, Foray's Restaurant served seafood and sandwiches 24 hours a day when this advertisement ran in 1949 and offered curb service near the corner of Labarre Road and Airline Highway. Across the highway, Pines Tourist Courts (2800) boasted "all rooms tile bath and refrigerator—Beauty Rest Mattresses" in 1944. By 1952, it had been renamed Rossi Motel Court, owned by S. Rossi. (JPYR.)

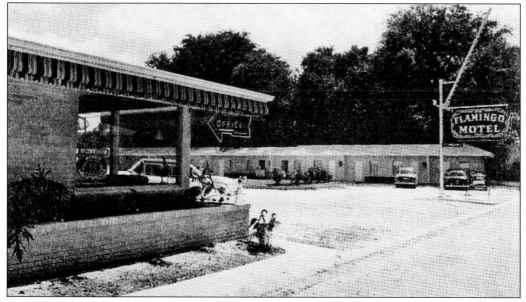

At 2935 Airline, the Flamingo Motel advertised "Comfort is Our Business" and "33 Refrigerated Units." The Flamingo also offered in-room telephones, televisions, ice, and a swimming pool at daily or weekly rates. The site is now occupied by the Cinema Motel, which can be viewed near the on-ramp to the Causeway traffic circle.

In 1946, the Delta Petroleum Company opened at the riverside corner of the Labarre Road/ Airline Highway intersection (3000 Airline), manufacturing and compounding lubricating oils and greases. Growing from its humble beginnings at this location, the company is now one of the largest independent lubricant manufacturers in North America. By the mid-1970s, it had expanded to handling other chemicals. Delta Petroleum now has plants in Denver, Colorado; St Rose, Louisiana (current headquarters); Bayonne, New Jersey; and Houston, Texas. The company owns Olympic Oil of Chicago, Illinois, and Vulsay Industries of Toronto, Ontario. In the 3300 block at 3375, the Southern Tavern was a restaurant and bar owned by W. H. Nicholas that was, during the 1950s, used as the Jefferson Parish jail. Another Metairie business used to house prisoners was the Metairie Bank, at 502 Metairie Road (later the Tall Oaks Bar). A jail at 3623 Airline Highway became a paint store, and a lockup at 3800 Airline Highway was, at one time, the Ebb Tide Lounge.

This fine neon sign sits atop the roof of Jefferson Lumber and Concrete Products at 3380 Airline (at Shrewsbury Road) in 1963. Jefferson Lumber specialized in wood and building products, Big Joe concrete blocks and bricks, and pre-cast steps. The Skyline Motel, located near Jefferson Lumber at 3300 Airline Highway, is now the Aloha Motel. (LDL.)

Suburban Bowling Alley offered "Pleasure— Bowling—Exercise" at the corner of Airline Highway and Shrewsbury Road. It was managed by Lynn P. Dominque and E. J. Dupepe when this advertisement was placed in the 1945 Jefferson Parish Yearly Review. In 1952, Horace C. Duke served as owner and operator. (JPYR.)

SUBURBAN BOWLING ALLEY

Pleasure — BOWLING — Exercise

NEW AIRLINE HIGHWAY AT SHREWSBURY ROAD

TEmple 4600

E. J. Dupepe Lynn P. Dominique

Metairie, Jefferson Parish, Louisiana

ST. REGIS

AIRLINE

3500 AIRLINE HIGHWAY
U. S. 51 — 61 — 65

SEAFOODS — GUMBO — CRAYFISH BISQUE
JEFFERSON ROOM AND ROOF GARDEN
——Orchestra Playing Nightly in Jefferson Room——
CATERING TO BANQUETS, PRIVATE PARTIES, WEDDING RECEPTION

The St. Regis Restaurant was located at Shrewsbury and Airline Highway (riverside at 3500) when this advertisement ran in 1950. It specialized in "Chicken in the Rough;" older folks may remember the sign atop the restaurant that featured a rooster playing golf with a broken club. The St. Regis cocktail lounge was a favorite of many Jefferson Parish political leaders. It was owned by Jimmie Beeson in 1956 but was destroyed by arson in the late 1950s. The adjacent St. Regis Motel typified the park-and-stay accommodations of that era. The Texas Court Motel stood in the same block at 3520 Airline (still there), and Graphia's Grocery was situated on the corner of Severn at 3529 (now a gas station). Down Shrewsbury Road near Metairie Road, the Little Forest Tourist Court advertised air-conditioning and "Everything Modern and Convenient" in 1941. Prout's Motel was tucked off the highway down Shrewsbury, advertising "new and modern" facilities in a 1965 listing that told of 30 units, private baths, reception and meeting facilities, two lounges, and a restaurant. Isaac Cyres, a chef at the New Orleans Hilton Hotel, was formerly the chef at Prout's. (JPYR.)

At 3600 Airline, Clarence Restaurant and Bar was open 24 hours serving steak, chicken, seafood, plate lunches, and oysters on the half shell at the corner of North Arnoult Road. An auto center now occupies the site. The Trade Winds Motel has been operating at 3616 Airline since at least the early 1960s and remains today. In 1949, A. K. Roy (3631 Airline) boasted developing the suburban neighborhoods Ridglake Edition, Woodlawn Acres, Severn Place, and Royland (in Harahan) and offered "acreage" along Airline Highway. A. K. Roy now operates from 108 Ash Street in Metairie. (LDL.)

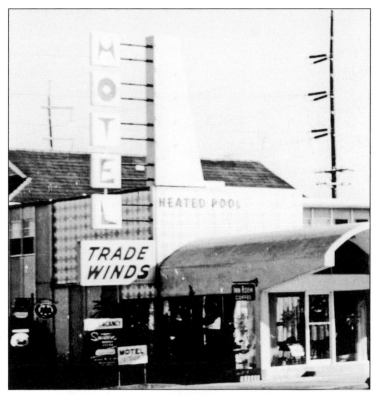

"Metairie's First & Finest," Metry Cab Service stood at 3716 Airline Highway near Labarre Road (now a McDonald's) until the company moved its office to the current location at 3625 Airline near Division Street (pictured). Metry Cab was incorporated in 1945. Kessler's Auto-Elec Automotive Parts, at 3701 Airline Highway, advertised engineered clutches, brake shoes, and "brake drums turned" in 1961. It is still there today. (JPYR.)

In this 1956 photograph, workers widen Airline Highway near Division Street. Terranova's Meat Market, at 3723 Airline, can be seen right of center. Also in the 3700 block were Lady's Lounge (3724), Jack's Fun House Lounge (3729), Continental Lounge and Grill (3731), and Burger King (3735)—the first in the New Orleans metropolitan area, on the corner of Division Street. In the 3800 block, Metry Tourist Court stood across the street at 3807 offering completely furnished apartments. The land is now occupied by a seafood outlet, a tattoo parlor, an advertising agency, and a computer repair business. At 3829, Ricca's Shop Rite Market is now a graphics business. In the 3900 block, Danna's Rock House (3901 at Cleary Avenue) served lobster and steak. The Joy Bowling Center stood at 3939 Airline Highway in front of St. Christopher's School. In 1965, part of the bowling alley building was used as the Joy Theatre. It is now an AutoZone. On the riverside, the Airline Drive-In was located near the Orleans Motel, which welcomed truckers to clean rooms. All businesses on this block have been replaced by a Sam's Club. (JPYR.)

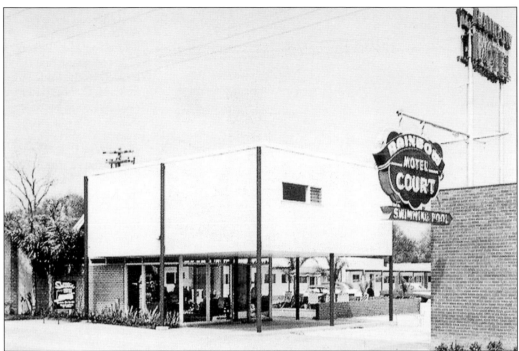

The Motel La Ville, at 4001 Airline Highway, was owned and managed by Carol and Sterling Laville, whose holdings included a playground and rooms with steam heat. In recent years, the building was demolished to make way for a Wendy's at the corner of Manson Avenue. The Sweet Home Motel was, and still is, on the corner of Central Avenue/Houma Boulevard at 4231 Airline Drive. The Sugar Bowl Courts continues to operate at 4303. In 1965, Harold Brockman managed the motel, which included a coffee shop, steam heat, and in-room phones. Pictured above is the Rainbow Motel, at 4307 Airline Drive, which is still in business (the address is also incorporated as Los Cuarteles Tortillas). The photograph at right, taken in 1960, allows a view through the glass-enclosed lobby to Gueydan Lumber and Plywood. It remains open. (LDL.)

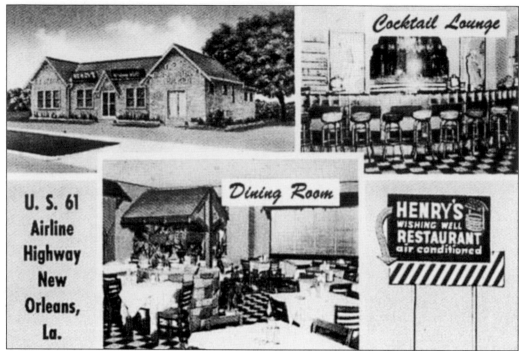

In the 4400 block at 4415, Henry's Wishing Well was owned and operated by Mary Mangano Onorato Henry, whose family's Mangano's Macaroni Factory was on St. Phillips Street in New Orleans for many years. It is now Lucky John's Bar. The D&B Food Store, once located at 4418, is currently a Walgreens.

In 1961, Friedrich's Manufacturing Company (pictured) stood at 4422 Airline Drive, but the site is now home to Glass Masters and Metairie Dependable Auto Sales. Mike's Famous Barbeque Steaks and Spaghetti House was located at 4505 in association with Mike's Motel. These businesses have given way to a gas station at the corner of Clearview Parkway. Henry's Rotisserie was situated at 4513 Airline in 1946; it is now Scandinavia Furniture. (LDL.)

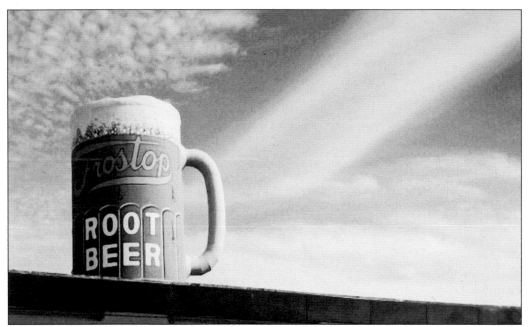

Just a couple blocks from East Jefferson High School, on the corner of Phlox Avenue and Airline Highway (4637), the Frostop Drive-in Restaurant was a popular place for burgers and root beer. Today Popeyes Chicken and Biscuits occupies the corner. This photograph captures a view of the huge mug atop the Frostop on Jefferson Highway in the Jefferson Plaza Shopping Center. It was taken the day before that location closed on January 30, 2007.

Occupying 65 acres (fronting six blocks along Airline Drive), the Garden of Memories/Woodlawn Memorial Cemetery was established in 1939 by Thomas James McMahon and was somewhat unique for New Orleans, with its below-ground single-use graves. It is one of the largest park-like areas in Jefferson Parish. During the 1960s, a mausoleum was added. Musician Gram Parsons and athletes Mike Miley and Ed Morgan are buried there.

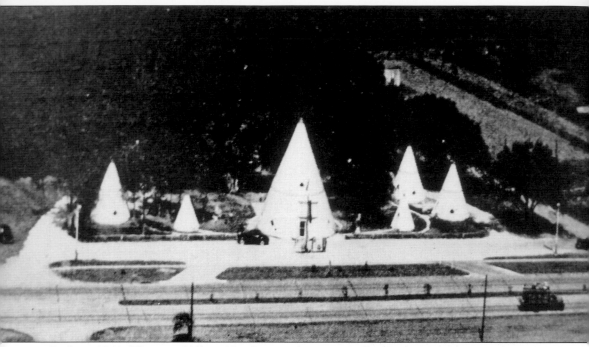

Built in 1940, Wigwam Village No. 3 invited guests to "Eat & sleep in a wigwam" in a 1941 advertisement boasting "THE MOST UNIQUE TOURIST HAVEN IN AMERICA—Quick Service and Courteous Treatment—E. A. Barielle, Prop." It was located five miles from downtown New Orleans on Airline Highway, likely between Transcontinental Drive and Clearview Parkway. The Metairie Wigwam Village included wigwam sleeping units, a restaurant and bar, an Esso service station, and a souvenir shop. One of seven Wigwam motels designed by Frank Redford, it closed in 1954. The others were situated in Cave City, Kentucky (two); in Birmingham, Alabama; near Orlando, Florida; in Holbrook, Arizona; and in San Bernadino, California. (JPYR.)

One of the nicest motels on Metairie's Airline Highway, the Candlelight Inn (4801) had heated pools, banquet and wedding reception services, and a Swedish smorgasbord long before all-you-can-eat buffets became commonplace. A Wendy's restaurant and Greff Motors now occupy the site on the corner of Zinnia Avenue. An orthopedic center in the 4900 block at the corner of River Street was once the location of Oak Park Cabins (4901), operated by John Lorino and Jerry Anselmo in 1941.

ONE OF THE GULF SOUTH'S MOST LUXURIOUS INNS

Air Conditioned • TV • Radio
Heated Pools • TV • Radio • Restaurant
Banquet & Wedding Reception
Service Etc.
Serving Delicious Swedish Smorgasbord

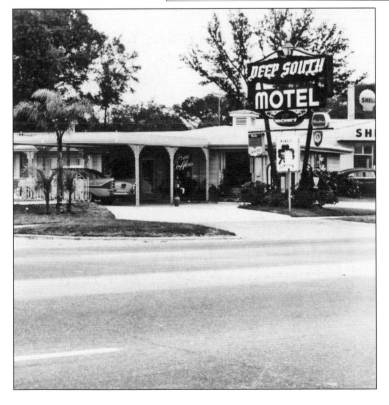

The Deep South Motel, pictured in 1959, stood at 5021 Airline Drive at the intersection with Transcontinental. Across the street at 5100 was Martin's Hotel Court. A Holiday Inn was situated at 5735 Airline; it is now the Travel Inn Plaza. At 5825, Rozal's Motel offered weekly and monthly rates across from what is now the New Orleans Saints practice field and training facility.

Within a year of becoming an NFL-franchised team, the New Orleans Saints began practicing, in 1967, at their training facility a block off Airline Highway between David Drive and Eisenhower Avenue on Saints Drive. In 1995, a two-alarm fire severely damaged the main building. The Louisiana legislature approved a new practice facility in 1993; ground-breaking ceremonies were held for the new site at 5800 Airline Drive in 1995. (LDL.)

The AAA New Orleans Zephyrs baseball team debuted at UNO's Privateer Park in 1993 before moving to the $21-million Shrine on Airline in 1997. In the aftermath of Hurricane Katrina, the stadium and field served as a staging area for rescue operations by the Federal Emergency Management Agency and the National Guard. Despite multimillion-dollar wind damage, the stadium reopened for the 2006 season with Zephyrs mascots, Boudreaux and Clotile, and their offspring welcoming a recovering, appreciative crowd.

Across from what is now Zephyr Field, this c. 1930s photograph of Tregle's Restaurant and Bar at 6113 Airline Highway illustrates the relatively rural and undeveloped nature of the surrounding area during the initial years after the highway's construction. Next door at 6115 Airline, Lou-Mar Restaurant and Bar served guests during the 1960s, as did the Dixie Bell Motel (6137). The Dixie Bell later became Passman's Restaurant, specializing in chicken, steak, and seafood "one block from Airline Shopping Center," and is now Airline Park Animal Clinic. The Good Luck Tourist Courts (now a daiquiri bar) stood at 6201. (LDL.)

Barnett's Furniture Store opened at 6303 Airline in 1961. Like many other New Orleans businesses, it added a new location in Metairie. Barnett's pre-existing stores were at 600 Carondelet and 4803 Chef Menteur Highway. This advertisement ran in 1963. Also in the 6300 block for decades were a Winn Dixie and Krystal Hamburger. (JPYR.)

GROWING
WITH JEFFERSON
and with the entire Greater New Orleans
Metropolitan Area

BARNETT'S

You are cordially invited to visit our new store
in Jefferson Parish at 6303 Airline Highway at
Airline Park!

Created from some of the last undeveloped land in Metairie, La Salle Park now offers walking and running paths, a stadium, basketball courts, and soccer fields. Plans are underway for the construction of a Jefferson Performing Arts Society center.

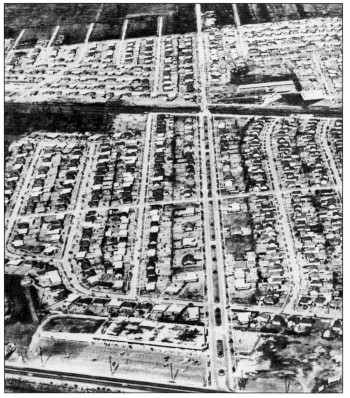

This aerial view includes Airline Highway (lower portion), Airline Park Boulevard (running north to south down the center), and the Airline Park subdivision in 1958. The western half of Airline Park Shopping Center (still in use) is to the left of Airline Park Boulevard. Among others over the years, the complex housed the VV Bike Shop, Krispy Krust Bakery, Shainberg's department store, Constantino's Pharmacy (now Cathay Inn restaurant), Arrow Shoe Repair, W. T. Grant department store (now AutoZone), and a National Food Store (most recently a Save-A-Lot). The shopping center stands across Airline Highway from what is now La Salle Park. (JPYR.)

When this photograph was taken in 1950, the incinerator on David Drive at Airline Highway (7201) was considered a modern means of handling municipal garbage. Processing 100 tons of garbage per day, it served the entire east bank of Jefferson Parish. Most residents simply called it "the Dump." It was recently demolished. (JPYR.)

The Airline Bowling Center, four blocks west of David Drive at 7401, was new when this advertisement ran in the Jefferson Parish Yearly Review in 1963. It was the first in the South to offer "Automatic Sparemasters." The location is now a Lions Club Bingo Hall. Down the road at 7875 was another McKenzie's Pastry Shoppe. (JPYR.)

At 8200 Airline Drive, Providence Park Cemetery was designed exclusively for African American burials. The legendary Mahalia Jackson rests there, along with James Booker and Leonard "Chick" Carbo Sr. The cemetery is located near the corner of Lynette Drive. Not far from Trudeau Drive at 8108 Airline, a Hoppers Drive-In was a popular haunt for young people in search of a burger, malt, and fries.

Five

VETERANS HIGHWAY AND THE CAUSEWAY

Camp Parapet, constructed in 1861 during the Civil War, stretched from the river to what is now Veterans Boulevard. It was captured by Union forces and used as a defense and training camp for African American troops. In 1914, "the Pit," a large area dug to obtain sand to make bricks used to build the camp, was filled to create Harlem Avenue (now Causeway Boulevard.)

In 1957, nearly 100 years after the camp's construction, the population of Metairie could be gauged by the two new million-gallon water towers that had been erected—one on Athania Parkway near Causeway and the other on Veterans Highway at David Drive. A checked design was applied to the David Drive tower so that pilots landing at the modern Moisant International Airport (now Louis Armstrong International Airport) could easily avoid it.

Metairie's growth has been discussed in earlier chapters. The Veterans Highway and Causeway areas were simply extensions of that expansion. But in 1972, a unique "city within a city" cropped up: local developers Ray Anselma, Joseph Peters, and Joseph Marcello and attorney David Levy laid out a plan to convert a parcel of land between Veterans Highway, Causeway Boulevard, West Esplanade, and Division Streets into an entertainment and apartment complex district. Local lore traces its name back to a snowball stand on Seventeenth Street near Severn that was operated by two teenage boys; it was called Fat City. Others claim the district was named for Fat City, the 1969 novel by Leonard Gardner, later made into a movie. Popular spots in Fat City included Melvin Facheaux's Dillinger's Night Club, which offered "Live Floor Shows—11 P.M. and 1 A.M." at 3612 Hessmer Street, and Glen's Restaurant at 3213 Arnoult Road.

Veterans was, and still is, the "new" highway in Metairie. There is no land remaining on which to plan another major road. Like Airline, Veterans Highway has undergone a name change—to Veterans Boulevard. A few blocks from the lake, Causeway Boulevard intersects with the highway and leads to the world's longest bridge: the Lake Pontchartrain Causeway.

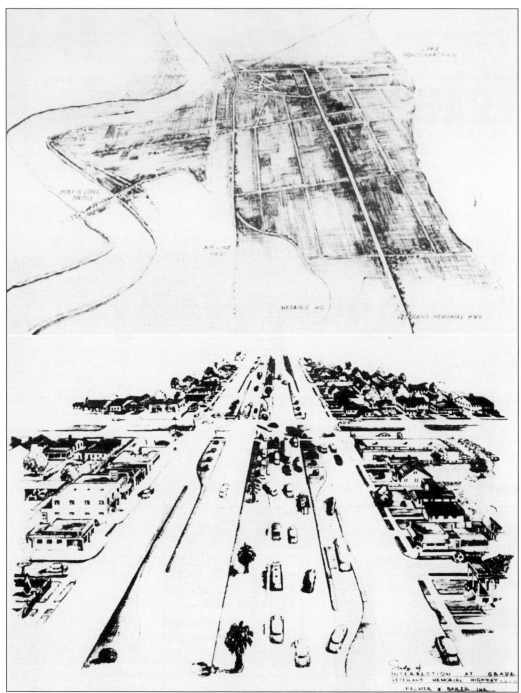

Palmer and Baker produced these sketches of the proposed Veterans Highway, appearing in the 1954 edition of the Jefferson Parish Yearly Review. With a $4-million budget, the highway was to include two three-lane expressways with service roads on each side. It would span Metairie from Orleans Parish to St. Charles Parish while running midway between Lake Pontchartrain and Airline Highway. Like several other early proposals, the plan did not completely pan out, as the service roads were never built. (JPYR.)

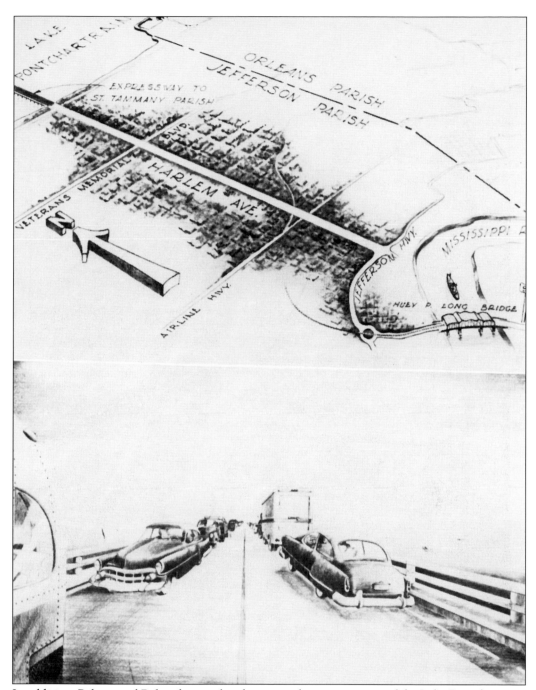

In addition, Palmer and Baker designed and oversaw the construction of the Lake Pontchartrain Causeway and Causeway Boulevard. Both are shown in the company's proposed views, which also ran in the 1954 edition of the Jefferson Parish Yearly Review. What would be named Causeway Boulevard was, at that time, still named Harlem Avenue. The caption to the images reads, in part, "The bridge over Lake Pontchartrain will be wide enough to proceed in the event of a breakdown on either of the two vehicular lanes." (JPYR.)

Veterans Highway was still merely an idea when this photograph captured the ground-breaking ceremony on February 18, 1954. John J. Holtgrove, president of the Jefferson Parish Police Jury, mans the tractor while other officials and workers pose. (JPYR.)

Moss-laced swamp cypresses bound the area where these workmen are building Veterans Highway in 1955. By this time, all east bank Jefferson Parish swamps and marshes had been drained and were either occupied or ready for development. Metairie's population had reached 50,000, and it was then recognized by the U.S. Post Office Department as an independent community with a first-class post office. (JPYR.)

The following views reflect a virtual drive down Veterans Highway in Metairie from east to west. After opening a grocery on Jackson Avenue in the Lower Garden District of New Orleans in 1947, Joseph Dorignac Jr. relocated the store to 710 Veterans Highway at Focis Street, just a few blocks from the Orleans Parish line, in 1963. This advertisement ran in 1975. The Dorignac's Food Center Web site (www.dorignacs.com) now proudly proclaims, "While the store's facade remains unchanged, so does its legacy." (JPYR.)

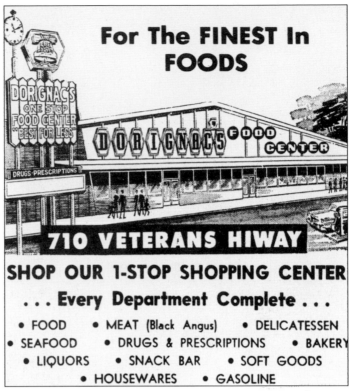

For The FINEST In FOODS

710 VETERANS HIWAY

SHOP OUR 1-STOP SHOPPING CENTER
. . . Every Department Complete . . .
- FOOD
- MEAT (Black Angus)
- DELICATESSEN
- SEAFOOD
- DRUGS & PRESCRIPTIONS
- BAKERY
- LIQUORS
- SNACK BAR
- SOFT GOODS
- HOUSEWARES
- GASOLINE

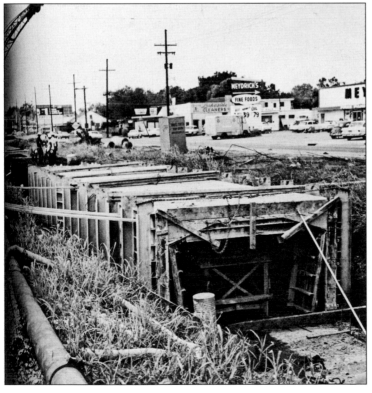

Less than a mile west of Dorignac's was Meydrich's Fine Foods, on the corner of Homestead Avenue at 1405 (now a pharmacy). The grocer also operated Meydrich's Venice Gardens Super Food Market on South Claiborne Avenue when this photograph was taken in 1967. Here workers fill in the canal running down the center of Veterans Highway. (JPYR.)

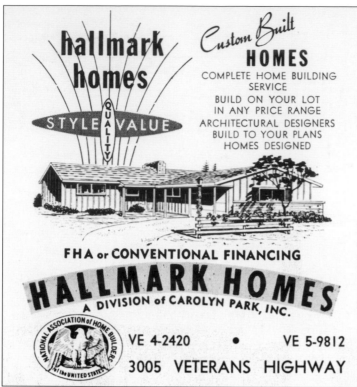

Hallmark Homes, on the corner of Tolmas Drive at 3005, was one of many active developers during the early years after Veterans Highway allowed easy access through central Metairie. This advertisement appeared in 1961. Other builders included Babin Homes, Baltazor, Delta, Drexel, Max Ferran, G&R, Happy Homes of Jefferson Parish, Heritage, Homes Ted, Lattie, Majestic Homes, Neyrey, Owen and Keppler, Ridgelake, Tobley Gelpi, Segall, Simonson, Weber, Willowdale, Sunrise, Manson Smith, Tolmas, Lauricella, Osborn, and Putnam. (JPYR.)

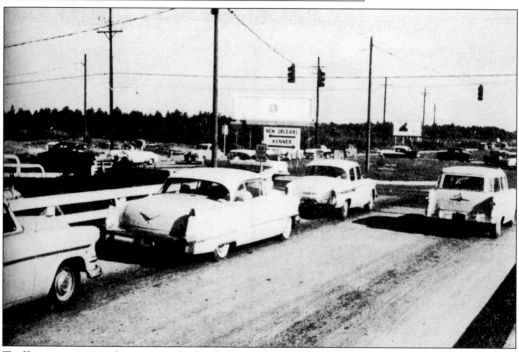

Traffic was growing, but not much development had taken place at the intersection of Veterans Highway and Causeway Boulevard when this photograph was taken in 1957. The sign in the center directs drivers to turn left to reach New Orleans or right to head toward Kenner. (JPYR.)

In 1959, the House of Lee was established on the corner of Causeway Boulevard at 3131 Veterans Highway by Chinese immigrants Bing Lee and Yip Shee Lee (the parents of Jefferson Parish sheriff Harry Lee), who had first operated a laundry on Carondelet Street in New Orleans. This popular restaurant served Chinese and American food "in Chinese Atmosphere" well into the late 20th century. The location is now a Borders Books. (JPYR.)

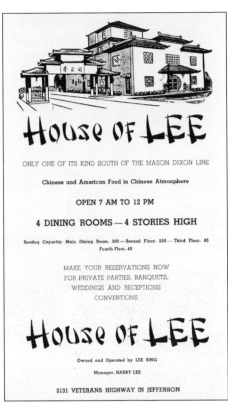

House of LEE

ONLY ONE OF ITS KIND SOUTH OF THE MASON DIXON LINE

Chinese and American Food in Chinese Atmosphere

OPEN 7 AM TO 12 PM

4 DINING ROOMS — 4 STORIES HIGH

Seating Capacity: Main Dining Room, 200 — Second Floor, 250 — Third Floor, 60
Fourth Floor, 40

MAKE YOUR RESERVATIONS NOW
FOR PRIVATE PARTIES, BANQUETS,
WEDDINGS AND RECEPTIONS
CONVENTIONS

House of LEE

Owned and Operated by LEE BING

Manager, HARRY LEE

3131 VETERANS HIGHWAY IN JEFFERSON

This 1961 photograph shows the new Lakeside Shopping Center at Veterans Highway and Causeway Boulevard. Considered a regional shopping center, Lakeside was built in the then-new mall style with an open-air, pedestrian-only central court. It was said to offer the largest parking facilities in the South. (JPYR.)

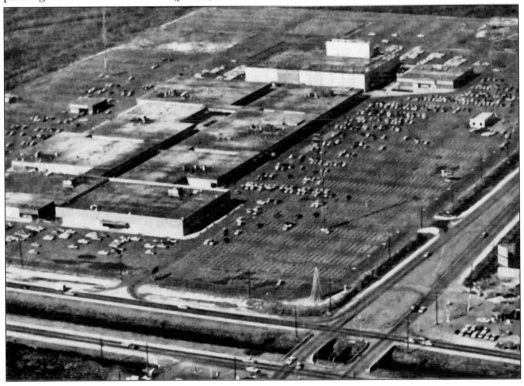

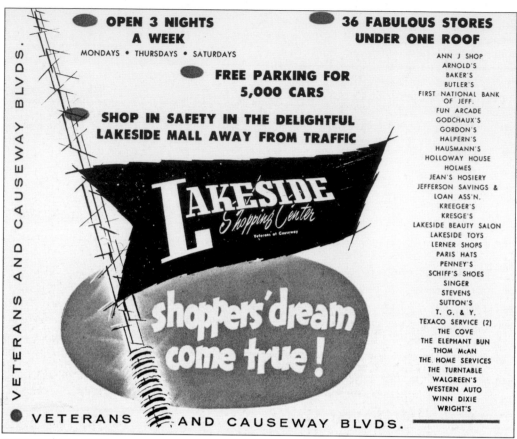

"A shoppers' dream come true!" and "36 fabulous stores under one roof," boasts this 1961 Lakeside Shopping Center advertisement. For the first time, D. H. Holmes, Godchaux's, and Kreeger's had opened off–Canal Street locations. The mall's one-stop-shopping experience included a TG&Y, Walgreens, Winn Dixie, and Western Auto. (JPYR.)

The modernistic lights at the Lakeside mall were the talk of the day and could be seen from miles away when this photograph was taken in 1962. The water tower on Athania Parkway, built in 1957, is visible just right of the light. Godchaux's department store appears to the right of the water tower. (LDL.)

This 1962 view of the interior of the Lakeside mall reveals that it is still an open-air shopping center. Stores shown here are the Turntable, Jean's Paris Hats, Holmes, and the Fun Arcade. (LDL.)

Holmes is proud to have two great stores a part of the magnificent air conditioned malls in the Lakeside and Oakwood Shopping Centers. Each stocked with vast selections of everything for your family and home.

When the Lakeside Shopping Center opened in 1960, it touted its stores as being "all under one roof," but the center court was open to the elements. It was enclosed and air-conditioned in 1968. In 1966, Holmes enlarged its Lakeside location but was still proud in 1975 to announce that its suburban stores in Metairie and on the West Bank were situated in enclosed, "magnificent air-conditioned malls." (LDL.)

By 1980, Causeway Boulevard between Lake Pontchartrain and Veterans Highway had become packed with businesses, both large and small. This view looks over the Lakeside Shopping Center to the Causeway twin spans. (LDL.)

The Clearview Mall at Clearview Boulevard was the second major shopping center along Veterans Highway. Some minor history was made there in 2002 when Target acquired the Maison Blanche location and added German-designed Vermaport escalators to transport shopping carts between floors. This was the first time Vermaport was used in the Gulf South area. (LDL.)

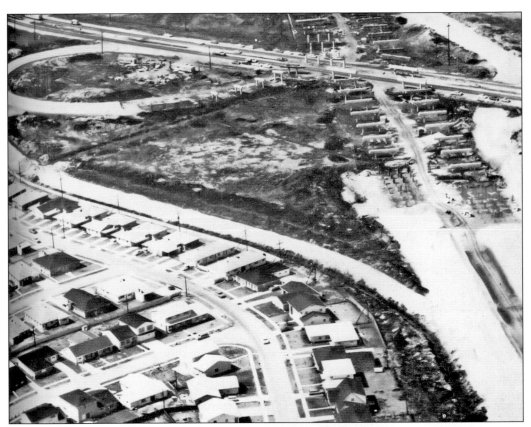

In 1965, Interstate 10 was being built through central Metairie. It would help ease traffic along the major highways and connect to the nationwide interstate grid. The above photograph shows Veterans Highway (running east to west near the top) as it intersects with the roadwork. Below is a 1966 view of interstate construction over the Seventeenth Street Canal and into Metairie. (JPYR.)

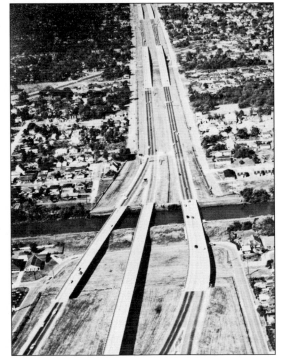

MAGNOLIA PARK INC. HARNESS RACING

Licensed and Supervised by The Louisiana State Racing Commission

1954 SEASON OPENS
September 23
For 45 Nights

8 RACES NIGHTLY
Clubhouse, Bar, Grandstand, Dining Room
Facilities For 20,000

In Jefferson Parish…on Frank J. Clancy Blvd. between Airline Highway and New Veterans' Memorial Highway

Felix Bonura served as president of the new 427-acre, multimillion-dollar pari-mutuel Magnolia Park. The harness-racing course opened in 1954 on Frank J. Clancy Boulevard (now Downs Boulevard) between Airline and Veterans Highways on a portion of the old La Freniere Concession. The company built a $100,000 road from Airline Highway to the track, which provided parking for 5,000 vehicles, seating for 2,500 in the grandstand, a dining area for 600, and accommodations for over 10,000 people on the grounds. Barns provided space for 600 horses on the 227-acre track. Magnolia Park also owned an additional 200 acres in the immediate area that was later used for housing development. The harness-racing season ran from September to Thanksgiving Day, when the New Orleans Fairgrounds opened for the year. In 1959, the track was renamed Jefferson Downs and offered nighttime horse racing. The track closed in 1965. The land later became Lafreniere Park, whose ground breaking was in 1977. The park was dedicated and opened to the public in 1982. (JPYR.)

This 1962 view of Veterans Highway at Power Boulevard/David Drive includes undeveloped area, power lines, and the shopping strip in which an A&P was located (now Big Lots). The strip also consisted of Morgan and Lindsey, McKenzie's Pastry Shoppe, Shoe Town, and Katz and Besthoff. The steel towers carried 230,000-volt lines from the LP&L Snake Farm substation, near Airline Highway at David Drive, across the lake and on to Bogalusa. (JPYR.)

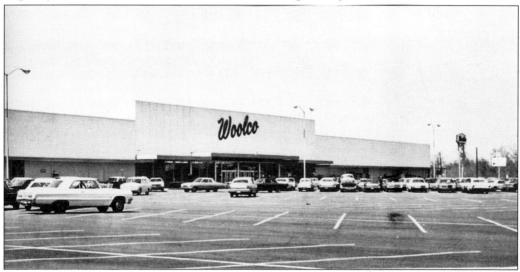

Straddling the Metairie/Kenner boundary, the "new and excitingly wonderful" Woolco department store opened its doors on Veterans Highway in 1968 just a block from the double-screen WestGate Drive-In, which showed its first films in 1966 at 8843 Veterans Highway. (JPYR.)

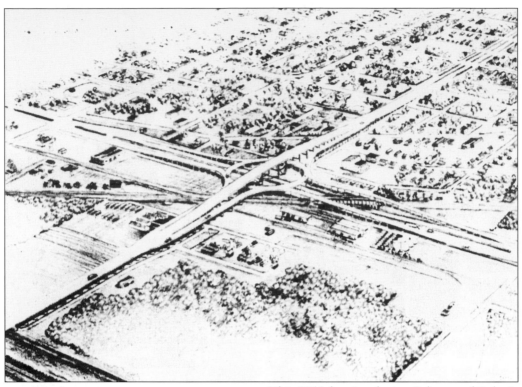

This 1956 drawing depicts Palmer and Baker's plans for the Causeway/Airline Highway traffic loop. The work was completed in 1957. In 1954, Sheriff John Clancy wrote, "We believe that one of the most popular portions of our Program of the Future for East Jefferson will be the proposed ELIMINATION OF GRADE CROSSINGS, with underpasses and overpasses. This requires not only the support of the people of the parish but the cooperation of the railroads and all industries and property owners whose holdings such improvements will affect." (JPYR.)

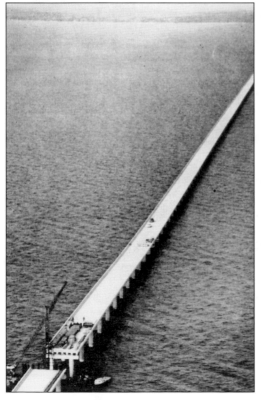

The 24-mile Lake Pontchartrain Causeway, which would be the world's longest bridge, is near completion in this 1956 aerial view. It was planned to connect Jefferson and Orleans Parishes to the north shore at Mandeville and to serve as a link in the direct route from Airline Highway to Jackson, Mississippi; Memphis, Tennessee; Chicago, Illinois; and other major cities from U.S. Highway 190 and from the Old Spanish Trail (Jefferson Highway in Jefferson Parish), which ran from California to Florida. (JPYR.)

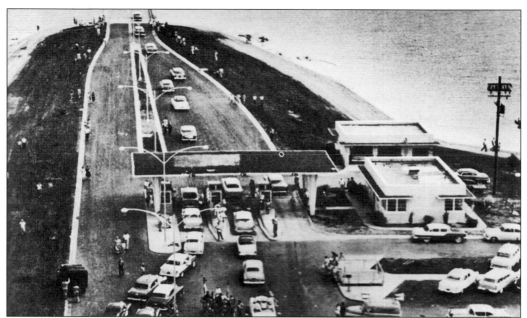

Cars line up on the Metairie terminus to make the first trip across the Causeway on its opening day, August 30, 1956. The bridge is composed of 2,246 spans of concrete with two bascules (drawbridges) for large passing vessels. The Causeway reduced a trip across the lake from the New Orleans metropolitan area from approximately 53 miles to 24 miles. (JPYR.)

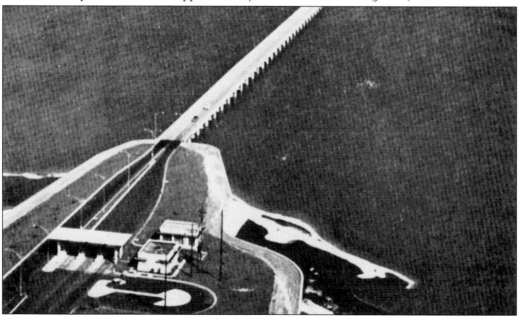

This 1961 aerial view of the Causeway accompanied a public relations announcement from the Greater New Orleans Expressway Commission stating the following: "The 24-mile-long Lake Pontchartrain Causeway is a magnificent symbol of the continuing progress of Jefferson Parish. . . . It connects busy, booming Jefferson Parish with St. Tammany Parish's famed Ozone Belt. Millions of vehicles have crossed the world's longest bridge since it was opened to traffic on August 30, 1956." (JPYR.)

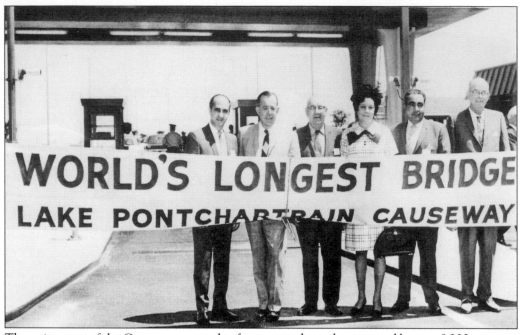

The twin spans of the Causeway are made of pre-stressed panels supported by over 9,000 concrete pilings. The two double-lane spans are separated by 80 feet of open space with seven crossovers that also function as emergency pullover areas. Shown here are local dignitaries on the opening day of the second span in 1969. (LDL.)

Maurice Walsh (left), an unidentified person (center), and Sallie Farell are present on the opening day of the Lobby Library, at 3420 North Causeway Boulevard, in 1966. The Lobby branch was unique in that one placed an order for a book, which was then picked up from a central counter. In 2003, after the Jefferson Parish Public Library moved its east bank headquarters to the new location at 4747 West Napoleon Avenue, this building was converted into the Causeway Head Start Center. (LDL.)

Members of the Sclafani family established their first restaurant in mid-city New Orleans in 1945, operated a restaurant and catering hall on Hayne Boulevard in New Orleans East for several years before Hurricane Katrina, and now run a cooking school in Old Metairie. The most famous of the Sclafanis' endeavors, however, was Restaurant Sclafani at 1315 North Causeway Boulevard. Constructed in 1958, the big, red-brick building was a landmark as well as the venue for many weddings, bridal showers, and special nights. The restaurant closed in 1985.

During the 1970s, a building boom occurred along Causeway Boulevard. Here a worker is silhouetted against the Jefferson Bank building. (LDL.)

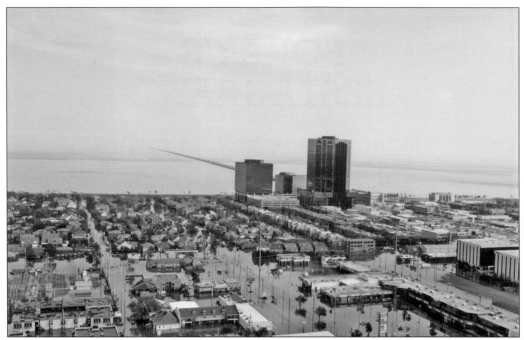

In the aftermath of Hurricane Katrina, large areas of Metairie were under water. This photograph, taken by the Federal Emergency Management Agency, captures a view of inundated homes and businesses near the Causeway at the lake. (Federal Emergency Management Agency.)

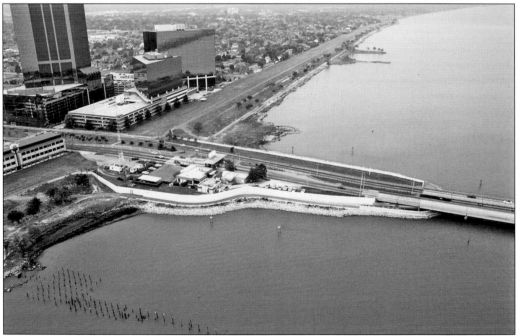

A post-Katrina view of the Causeway shows the newest high-rise constructions near the bridge as well as a panorama of the Metairie shoreline at Lake Pontchartrain. The Bonnabel boat launch appears in the upper right center. The pilings of a long-lost camp survived Hurricane Katrina and can be seen at the lower left. (U.S. Army Corps of Engineers.)

BIBLIOGRAPHY

Buchler, Miriam Bonnabel Lacey. *The Legacy of the Bonnabels to Jefferson Parish.* Metairie, LA: Jefferson Historical Society, 2000.

Jefferson Parish Yearly Review: An Annual Progress Report of Jefferson Parish Louisiana. New Orleans: Parish Periodicals, 1935–1983.

Kendall, John Smith. *History of New Orleans.* New York: Lewis Publishing, 1922.

King, Grace Elizabeth. *New Orleans: The Place and the People.* New York: Negro Universities Press, 1968.

Louisiana Digital Library, Charles L. Franck Collection.

Louisiana State University School of Landscape Architecture, Office of Sea Grant. *Bucktown, New Orleans, Louisiana: Rebuilding for a More Flood Resistant Future.* Baton Rouge, LA: Louisiana State University, Office of Sea Grant, 2006.

Thocdc, Henry J. *History of Jefferson Parish and Its People.* Gretna, LA: Distinctive Printing, 1976.

Whitbread, Leslie George. *Placenames of Jefferson Parish Louisiana.* Metairie, LA: Jefferson Parish Historical Commission, 1977.

The author purposely did not include Msgr. Henry C. Bezou's *Metairie: A Tongue of Land to Pasture* (1973) and Betsy Swanson's *Historic Jefferson Parish: From Shore to Shore* (1975) as research sources in an effort to prevent the duplication of information found in these major texts.

Across America, People are Discovering Something Wonderful. Their Heritage.

Arcadia Publishing is the leading local history publisher in the United States. With more than 4,000 titles in print and hundreds of new titles released every year, Arcadia has extensive specialized experience chronicling the history of communities and celebrating America's hidden stories, bringing to life the people, places, and events from the past. To discover the history of other communities across the nation, please visit:

www.arcadiapublishing.com

Customized search tools allow you to find regional history books about the town where you grew up, the cities where your friends and family live, the town where your parents met, or even that retirement spot you've been dreaming about.